C000098384

BETWS-Y-COED, LLANRWST AND TREFRIW

THROUGH TIME

John Barden Davies

AMBERLEY

First published 2015

Amberley Publishing Plc
The Hill, Stroud, Gloucestershire, GL5 4EP
www.amberley-books.com

Copyright © John Barden Davies, 2015

The right of John Barden Davies to be identified
as the Author of this work has been asserted in
accordance with the Copyrights, Designs and
Patents Act 1988.

ISBN 978 1 4456 5089 0 (BOOK)
ISBN 978 1 4456 5090 6 (E-BOOK)

All rights reserved. No part of this book may be
reprinted or reproduced or utilised in any form
or by any electronic, mechanical or other means,
now known or hereafter invented, including
photocopying and recording, or in any information
storage or retrieval system, without the permission
in writing from the Publishers.

British Library Cataloguing in Publication Data.
A catalogue record for this book is available from
the British Library.

Typesetting by Amberley Publishing.
Printed in the UK.

Contents

Introduction

Betws-y-Coed

Betws-y-Coed came into prominence in the nineteenth century when artists began to appreciate its spectacular scenery. Pont-yr-Afanc (Beaver Bridge) and the Waterloo Bridge improved access to Betws and artists set up a colony at the Royal Oak hotel. Betws was still a quiet place then but when the railway came in 1868 it brought in many tourists and many guest houses were built as a result. The artists felt disturbed by this commercial growth and many of them moved down the valley to Trefriw and later to Llanbedr and Rowen where it was quieter. Today, Betws, with its beautiful scenery and its location at an important road junction, is an increasingly popular resort visited by people from all over the world.

Llanrwst

Grwst founded a church here in the sixth century but when Edward I built the town of Conwy in the fourteenth century and forbad Welsh people from trading within ten miles of that town, Llanrwst developed as a market town and became a centre for wool trading and later well known for the manufacture of harps and clocks. In 1276 Prince Llywelyn declared Llanrwst an independent free borough, hence the saying 'Wales, England and Llanrwst'. The town's most prominent feature is Pont Fawr (Llanrwst Bridge) built in 1636 and designed by Inigo Jones. The bridge remains largely unaltered to this day. Llanrwst, with its good selection of shops, remains the market town for the Conwy Valley and is an important cultural centre.

Trefriw

Llywelyn the Great had a residence here in the twelfth century. By the beginning of the nineteenth century Trefriw had become a river port from which local products were shipped. When the railway opened to Llanrwst in 1863 the shipping trade declined but the tourist era began. Gower's Bridge was built in the 1870s to link Trefriw with Llanrwst railway station. Tourists were attracted to the spa and people came to Trefriw on paddle steamers from Conwy. Another tourist attraction is Trefriw woollen mill, owned by the same family since 1820. Today, Trefriw is a quieter place but people still visit the mill. The spa is now closed to the public but continues to supply its product on a commercial basis.

Betws-y-Coed

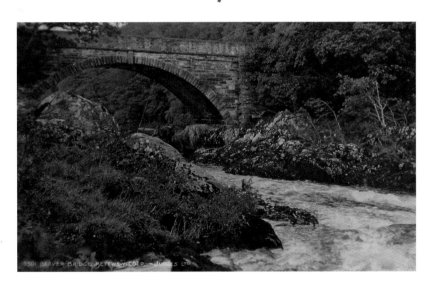

Pont-yr-Afanc (Beaver Bridge)

Communication around Betws-y-Coed was improved with the building of Pont-yr-Afanc in 1808 as it allowed the London to Holyhead coaches to pass through Betws. Although 'afanc' is usually translated as 'beaver', it is associated with a local legend of a monster which lived in the pool known as Pwll-yr-Afanc. The legend says that people believed the monster to be the cause of floods in the valley and that ways were sought to get rid of it. According to the legend, the afanc was enticed out of the water and then put in chains and towed by a team of oxen to a lake high in the mountains where it was released, never to be seen in the valley again.

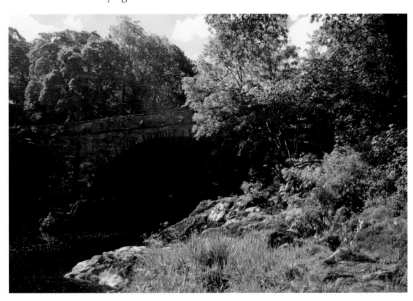

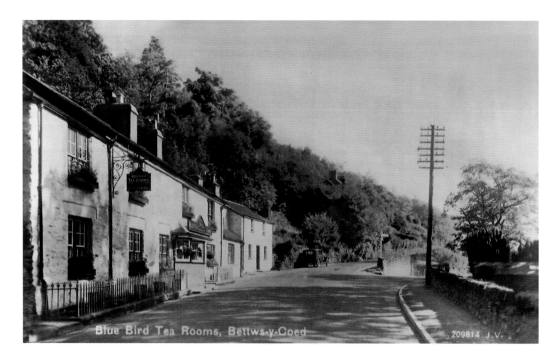

Blue Bird Tea Rooms, Bettws-y-Coed

209814 J.V.

Blue Bird Café/Tŷ Gwyn

By the mid-twentieth century this building had become the Bluebird Tearooms and its convenient location on the A5 within easy walking distance of Betws meant that it was very popular. The road in the photograph above is so quiet that there are no problems for the solitary old car parked outside, whose occupants are probably enjoying tea. The road to Blaenau Ffestiniog is on the right but notice the simple road sign which was very adequate for those times. The building is now the Tŷ Gwyn hotel and restaurant.

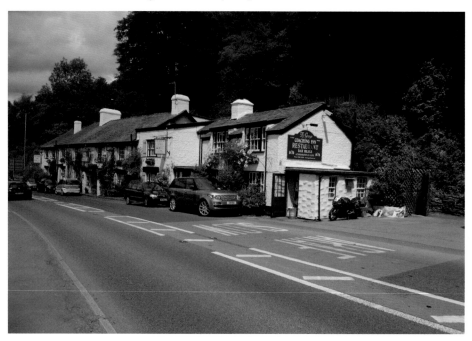

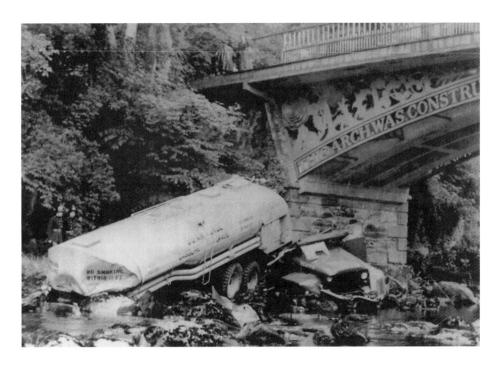

Waterloo Bridge

An inscription on the bridge states that it was built in 1815, the year of the battle of Waterloo. This was actually the year the iron ribs were made, but the bridge itself was built in 1816. It replaced Pont-yr-Afanc as the main crossing of the river Conwy and made for an easier passage for the London to Holyhead coaches. Four years later, Telford built his improved London to Holyhead road and once again communication was improved. There is a sharp turn onto the bridge and some vehicles have been known to go over the top. The modern motorist is grateful for the double railings now on the bridge.

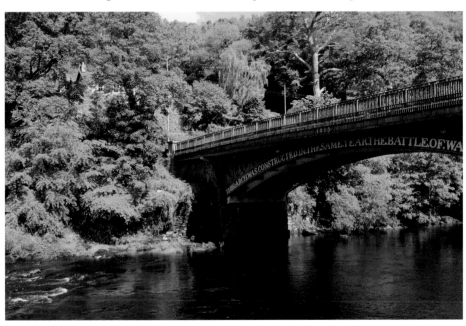

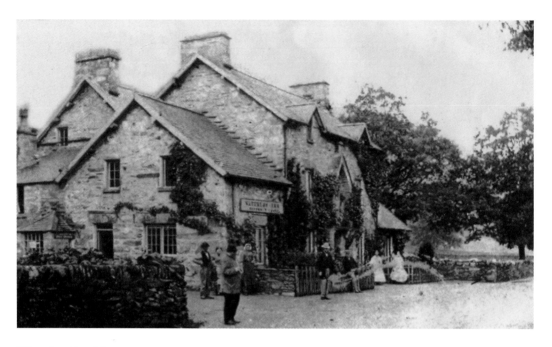

Waterloo Hotel I

When the Waterloo Bridge was built over the River Conwy people came to Betws in increasing numbers. In those days when people travelled by horse and carriage, they needed inns to stop for refreshment and to rest the horses, also to provide overnight accommodation. The first Waterloo Hotel was built in 1856 but after the coming of the railway in 1868 it soon became too small and a second hotel was built. This larger building catered for the increasing number of visitors who came by train.

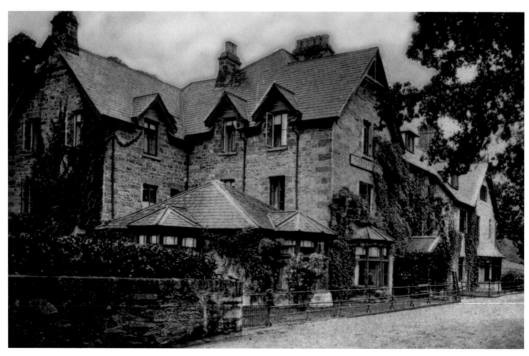

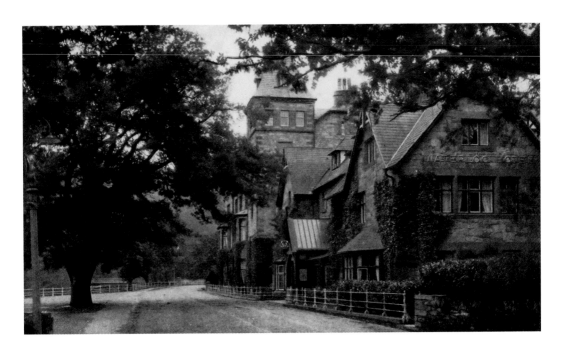

Waterloo Hotel II

By the turn of the nineteenth century, even the second hotel had become too small and this impressive building with its majestic tower was built to cater for even more visitors who now came by car as well as by train. The hotel stands in an ideal position being the first hotel people see after they cross the Waterloo Bridge. This impressive hotel is still fondly remembered by many but in the 1960s it was demolished to make room for road widening and replaced by the equally impressive fourth hotel which stands today and offers modern facilities for the tourist.

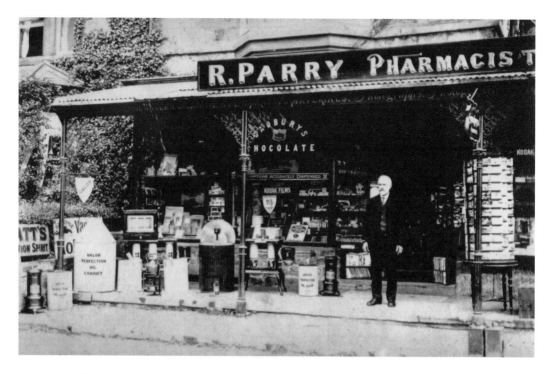

Pendyffryn

In addition to being a pharmacy, Parry's sells a wide range of items from oil drums to paraffin heaters and from birthday gifts to anniversary gifts. The shop remained a pharmacy until comparatively recent times and some of the older people in the village still refer to it as 'the chemist'. However, for some years now it has been a newsagent and general store with a hairdresser upstairs. In its convenient location on the A5 the shop with parking available outside, is popular with locals and with passing trade.

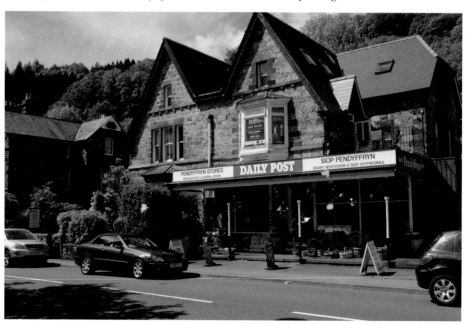

De Eresby and Willoughby Houses

The names of these houses refer to the owners of the Ancaster Estate, the Barons Willoughby de Eresby who inherited the local Gwydir Estate in the seventeenth century. The Gwydir Estate owned most of the land in the area. In the picture above the buildings are occupied by a general store and a guest house. The ever-present horse is parked outside the general store. Today, de Eresby house is occupied by an art gallery selling good-quality pictures that are painted by the artist who owns the shop. This shows that the old connection between Betws and artists is still very much alive. Willoughby house is now occupied by a branch of HSBC bank.

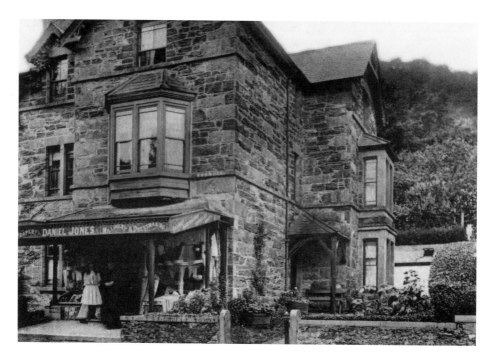

Fron Deg

At the time when Daniel Jones' shop on the main Holyhead Road was a thriving business, people would buy clothes to order, which would be made in the shop, or purchase the cloth from the shop so as to make their own clothes. In later years the need for such shops declined and people bought ready-made clothes either locally or further afield in the larger towns. Fron Deg has had many occupants since it ceased to be a drapery shop. Various gift shops have occupied the premises over the years, and people will remember it as a shop selling brass items.

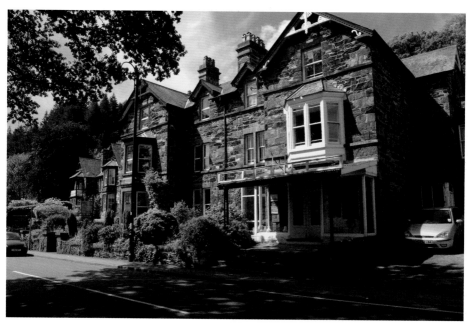

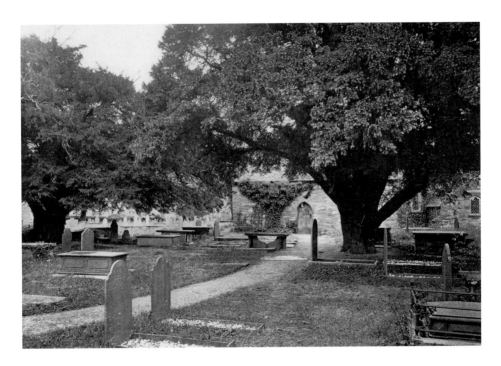

St Michael's Church

This fourteenth-century church was initially in the township of Betws Wyrion Iddon and was also known as Llanfihangel-y-Betws. From the 1820s onwards more visitors came to Betws-y-Coed and the population increased. This resulted in the church being enlarged in 1843. After the railway came in 1868, even the enlarged church proved to be too small so St Mary's church was built. Inside St Michael's is a carved effigy of Gruffudd ap Dafydd, a prominent local land owner. One theory suggests that he was a descendent of Llywelyn the Great and younger brother of Llywelyn ein Llyw Olaf, the last indigenous Prince of Wales but there is no definite proof of this.

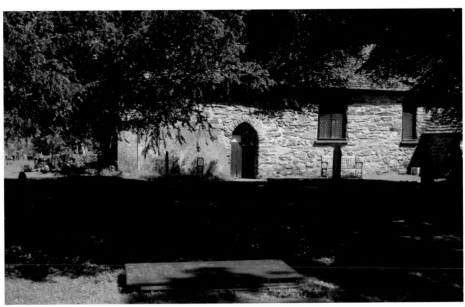

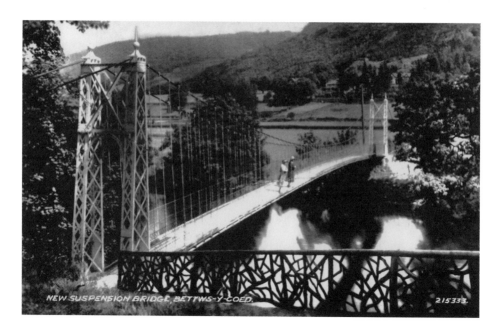

Sapper's Bridge

This bridge links Betws with the A470 road on the other side of the river. It is thought that there were once stepping stones here. The present bridge (seen in both pictures) was built in 1930 by the Royal Engineers for an army camp which was at that time in this location. It replaced a wooden bridge which was washed away in a storm. The bridge is next to St Michael's church and also near the railway station, it provides a useful shortcut to the centre of the village.

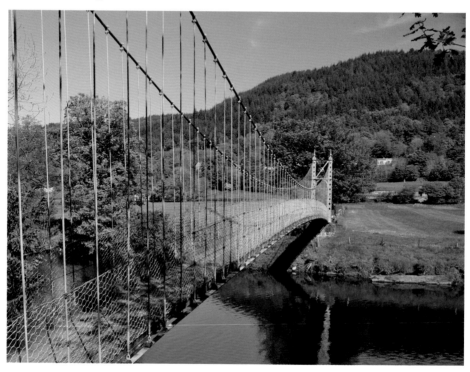

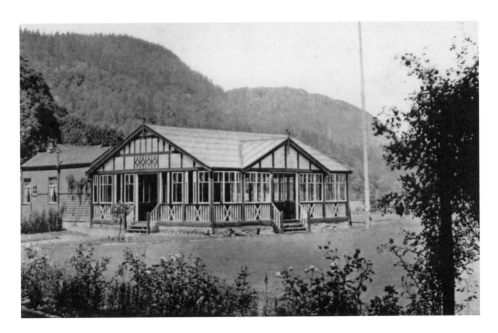

The Pavilion

This wooden pavilion was built near the river in the early twentieth century on land where the golf course now stands. It must have been a pleasant and quiet place to spend time to relax and maybe partake of afternoon tea, with views over the attractive rose garden in the front and the river at the back. The building was later burnt down and never replaced. The modern picture is taken from approximately the same location but looking across the River Conwy which gives an indication of the view that could be enjoyed from the pavilion.

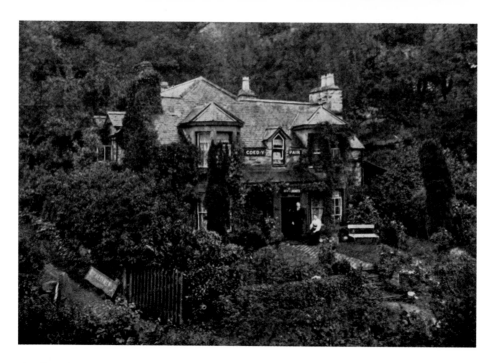

Coed-y-Pair

Coed-y-Pair was a typical Victorian guest house. Many such houses were built in the late nineteenth century. The picture is taken from an advertising postcard and it was usual in those days for such cards to have a picture of the proprietors. It was demolished in the mid-twentieth century and Our Lady of the Woods Roman Catholic church was built on the site for an increasing number of visitors. After about forty years of use as a church, the building became a place to accommodate climbers and walkers. Betws has plenty of accommodation from luxury hotels to bunkhouses; in fact when all of these are full the visiting population exceeds the resident population

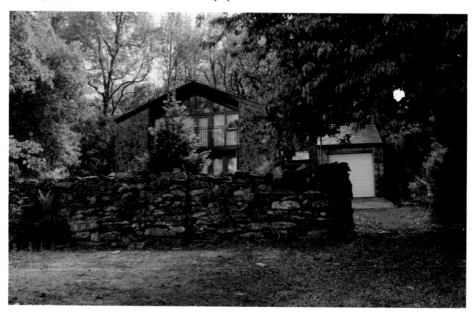

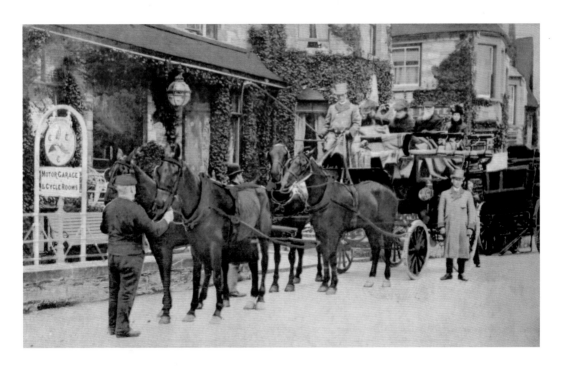

Glanaber Hotel

This is a splendid early twentieth-century picture of a horse-drawn carriage at the Glanaber hotel. Notice the well-dressed occupants and carriage footmen. There is no shortage of blankets on board because they had been on a trip through the Snowdonia mountains where the wind can be cold at any time of the year. The sign 'motor garage' indicates that the age of the horse and carriage is giving way to the age of the motor car. There is no indication of a garage on the modern picture, but mountain bike hire is on offer and the hotel also serves as a bunkhouse which is popular with cyclists and hikers.

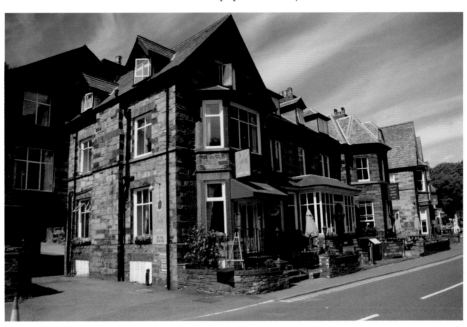

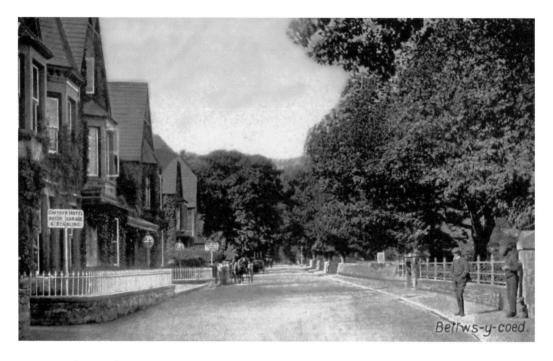

Gwydyr Hotel

The Gwydyr, which is one of the largest hotels in Betws-y-Coed, began its life as a private residence in the early 1800s. Following the rapid growth of tourism in the village in the latter half of the nineteenth century, the Gwydyr was extended in the 1880s into the building that still stands today. It was popular with early rail travellers as it is the first hotel that rail passengers see. The hotel has run the Gwydyr Fishery for a century and a half and remains a popular place to stay for those seeking a fishing holiday. The hotel has recently been refurbished.

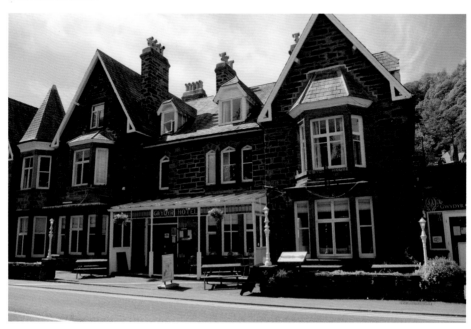

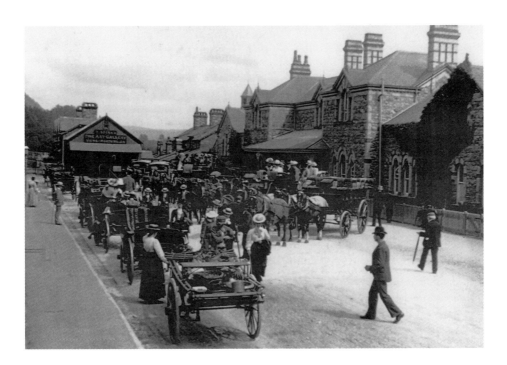

Road/Rail Interchange

This busy scene at the entrance to Betws-y-Coed railway station is a late nineteenth-century road/rail interchange. The passengers who got off the trains had probably come from Llandudno and other resorts on the coast for a day trip. The horse-drawn vehicles would be taking people to various destinations in Snowdonia. Today Betws station remains an important road/rail interchange. This service is popular with hikers and walkers who can get a bus, then take a walk. then return by bus by another route. The bus in the picture offers a bus/rail alternative in the Conwy Valley.

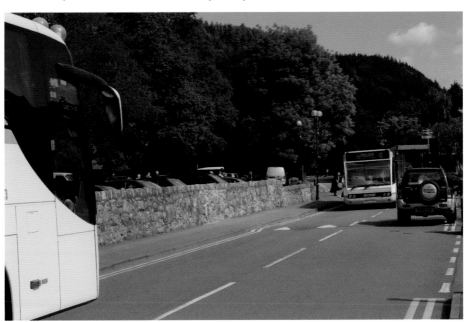

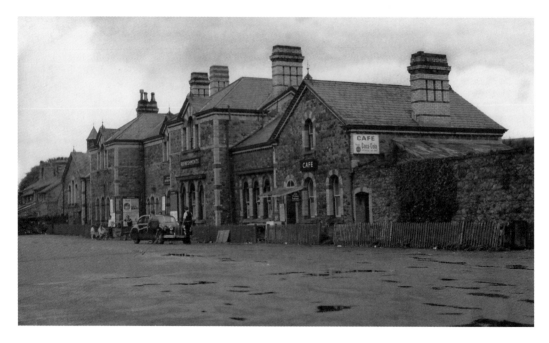

Railway Station Building

This photograph shows Betws station in the winter during the 1950s after what looks like a heavy shower of rain. The impressive station building provided full passenger facilities and had a staff of station master, clerks and porters. At this time the station handled mail and parcels with many of the supplies for the shops and hotels arriving by train. By today, the station building has been modernised and extended and now in private ownership provides extensive shops with locally sourced food and souvenirs which prove popular with visitors travelling by coach and by car as well as by train.

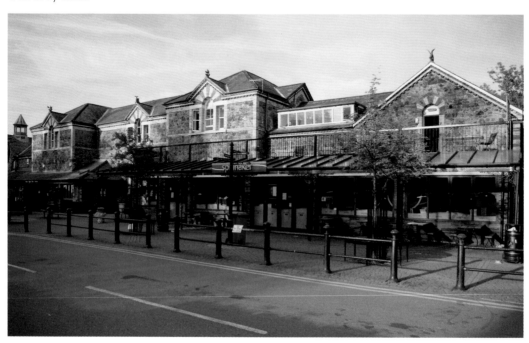

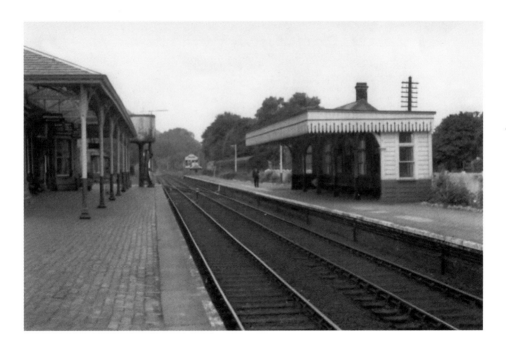

Railway Station Platform

Betws was (and still is) the largest and busiest station on this twenty-seven-mile branch line. In the 1950s rail facilities were extensive and both platforms have a covered waiting area. See also the water tower, probably needed because of the very steep gradient on the next section of the line. Near the signal box can be seen two camping coaches where families could stay at a very reasonable rate provided they travelled there by train. Today there is one platform and the former goods yard is now occupied by the Conwy Valley Railway Museum, a most interesting place for all the family to visit with its miniature railway and tram rides as well as museum exhibits.

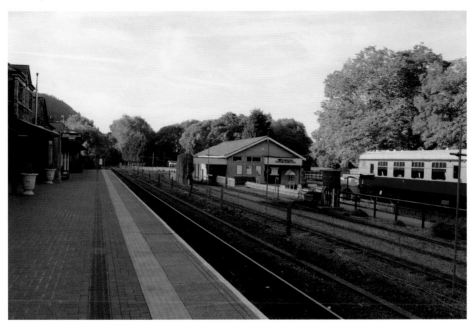

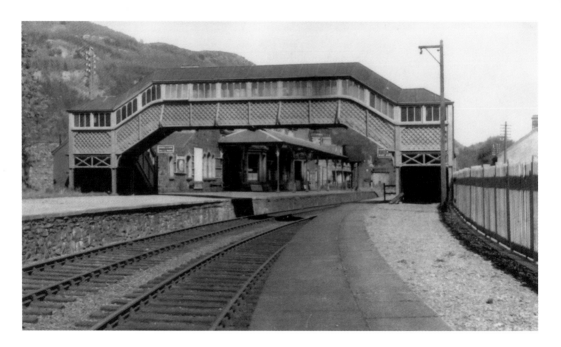

Station Footbridge

It was only important stations that were provided with covered footbridges and this was one such station. It must have been very welcome to passengers using the station on one of the many rainy days experienced in Snowdonia. However, the cover has long since been removed. Although the bridge no longer links the two platforms, it provides a useful short cut between the station and railway museum and also to St Michael's church. Notice the 'new' extension to the station buildings which provide various retail outlets.

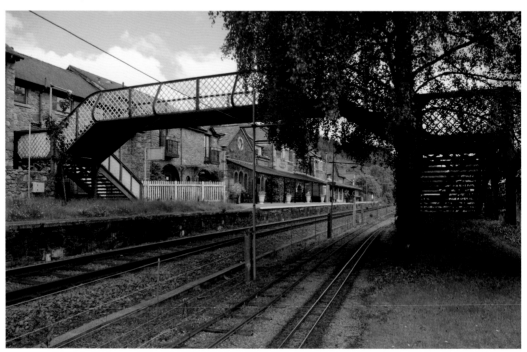

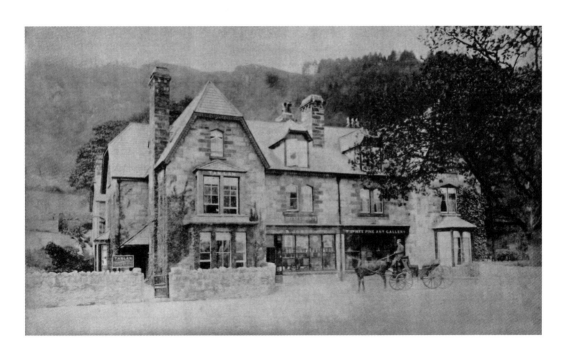

Tan Lan

Tan Lan, bakery, café and hotel was popular with generations of tourists and local people. The horse and small carriage in the late nineteenth/early twentieth-century picture (above) was probably taking people who had arrived at Betws by train from other parts of Snowdonia and had stopped at Tan Lan for refreshment. Spinx fine art shop is an indication of the popularity of the village with artists. By the 1920s/30s (below), times had changed and Tan Lan was catering for cyclists and motorists. The fine art shop has become Judges Postcards which is maybe an indication that the artist has given way to the photographer.

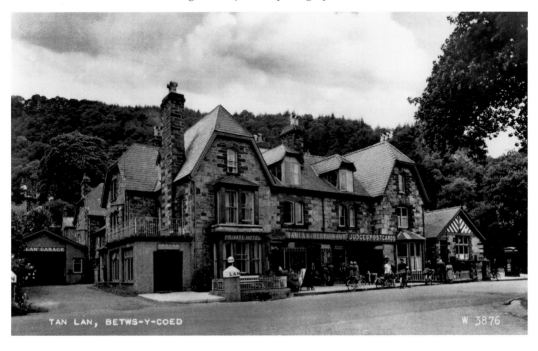

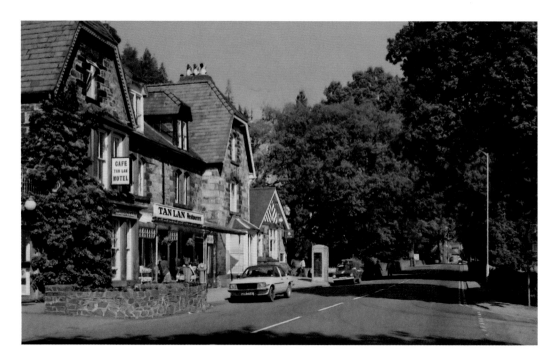

Judges

This mid-to-late twentieth-century picture (above) shows that more motorists are visiting Betws. Despite there being only two vehicles in the picture, the double yellow lines are an indication that parking restrictions have now become necessary. At that time, Tan Lan continued to provide refreshments and the post office can be seen next to Judges shop. Today, Tan Lan has been replaced by Millets Outdoor Shop but Judges still sells postcards of scenic local places and is an excellent location for visitors to buy their postcards and souvenirs. It is run by the Jones family, who have been a great help in the preparation of this book.

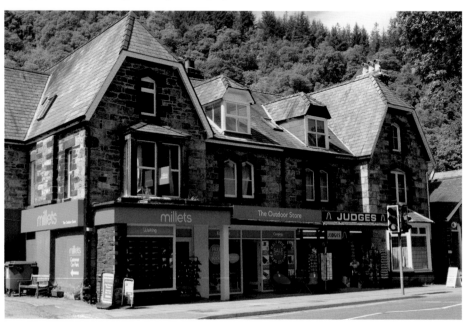

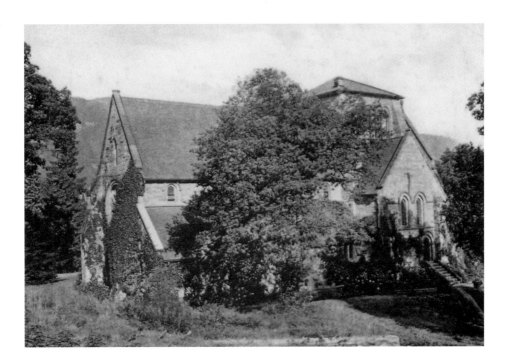

St Mary's Church

By the second half of the nineteenth century the resident and tourist population of Betws had greatly increased, and the old church of St Michael was no longer big enough. As a result of this, the impressive St Mary's church was built in 1873 and the tower was added in the early twentieth century. The church was built by local stonemason Owen Gethin Jones who also built the railway station building and Gethin's railway viaduct. Local legend says that every time he passed the church he would look away because he lost money on the deal. The church remains an active place of worship and hosts popular summer choir concerts.

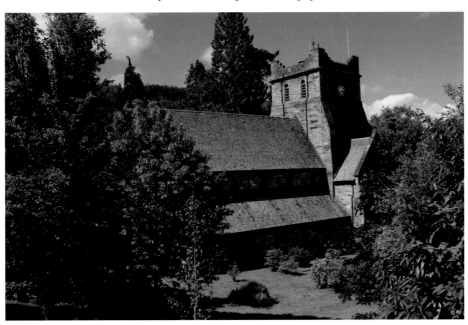

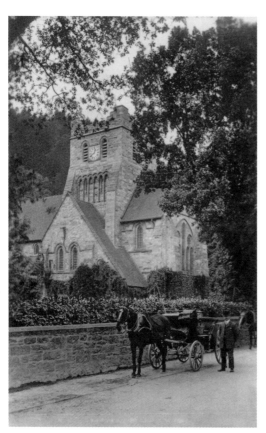

Transport from Church

This leisurely scene shows a horse-drawn vehicle waiting outside St Mary's church on the A5. It is probably waiting for its occupants to come out of church and take them to their home or hotel. It appears to be in very good condition and somewhat of a luxury vehicle for its day. Notice the other horse on the right of the picture. It is probable that a number of such vehicles are also waiting out of shot. The modern scene is little changed except that motor vehicles have replaced the horses and the trees have grown and now obscure the church tower.

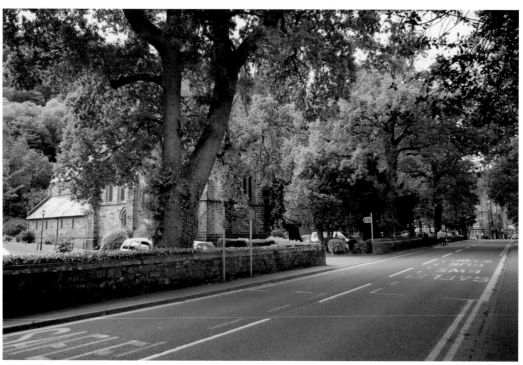

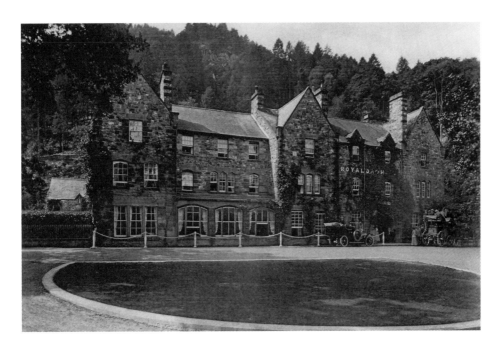

Royal Oak Hotel I

This hotel was of great significance in the beginning of Betws as a tourist destination. It opened in 1861 and has an association with the 'artists' colony' set up in the 1840s by famous artist David Cox in an older hotel on the same site. He painted an inn sign for the Royal Oak which is now displayed inside the hotel. When the number of tourists increased from the 1860s onwards, the Royal Oak was extended but it became less popular with the artists who missed the quiet atmosphere after the tourists arrived. They moved down the valley to Trefriw, Llanbedr and Rowen where it was quieter.

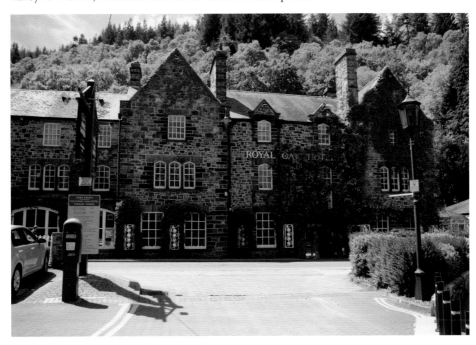

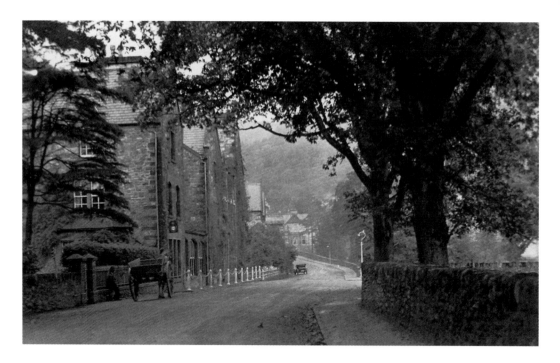

Royal Oak Hotel II

This 1910s picture which looks towards Pont-y-Pair from the Royal Oak, shows a time of transition from horse and cart to motor transport. The electric street lights were among the first to be installed when the village got its electricity supply in 1913. The scene is little changed in the modern picture except that the old car has been replaced by a new one. The Royal Oak remains a busy hotel today for staying guests and for locals and visitors to dine in its popular restaurants. Next door to the Royal Oak is Anna Davies' Welsh wool shop, a quality store which has been in the ownership of the same local family since its inception in 1956.

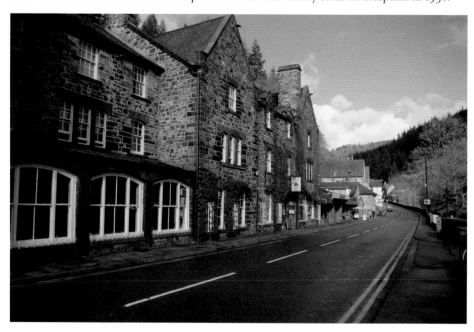

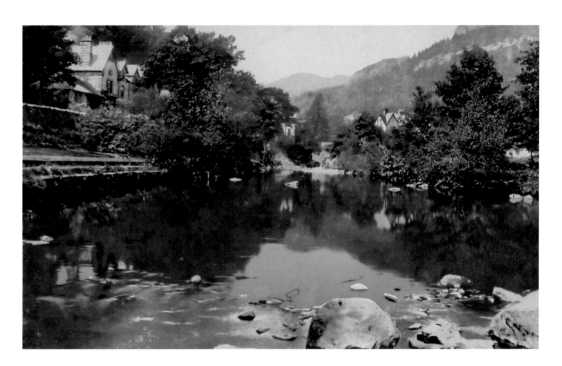

River Llugwy

Betws-y-Coed is the meeting place of three tributaries of the River Conwy (the Llugwy, Lledr and Machno). Rivers can take on many moods, none more so than the Llugwy which starts its life in the mountains of Snowdonia and flows through the mountain village of Capel Curig and tumbles down the Swallow Falls and cascades over the rocks at Pont-y-Pair. As it runs alongside the main A5 road, the Llugwy becomes somewhat calmer as it reaches the point illustrated here where it flows opposite the Royal Oak hotel. It is so calm that it takes on the appearance of a pool and has not changed over the intervening years.

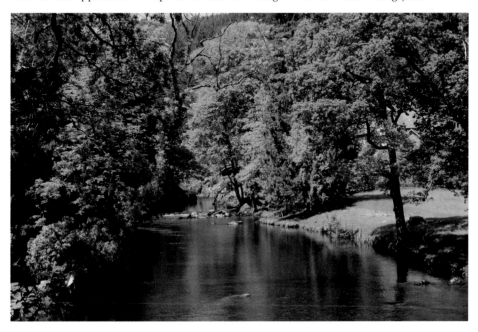

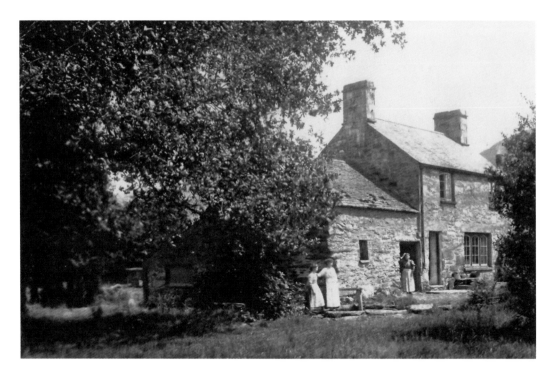

Royal Oak Farm

Although at some time in its history the Royal Oak Farm supplied food for the hotel of the same name, the house is probably older than the hotel. There is a mill at the farmhouse which is said to date from the thirteenth century, so it is much older than the mill that was situated in Mill Street. It was originally a grain mill but has also been a butter mill. Although the mill is still in situ it has not been used for a very long time. The house now provides tourist accommodation in this peaceful and tranquil setting.

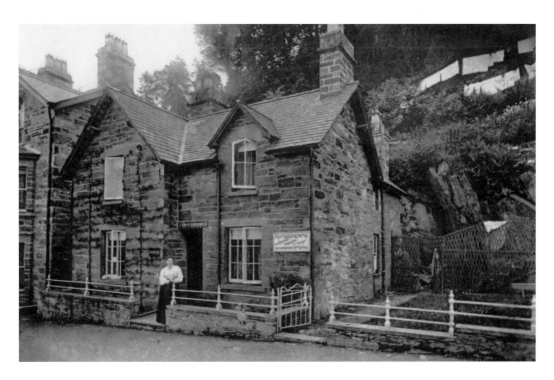

Tandderwen

Tandderwen, on the A5 road, is offering an extensive range of refreshments to the traveller with the usual advertising picture with the proprietor standing by the gate. The amount of washing on the line indicates bed & breakfast was available. It must have taken some agility to climb up to put the washing out and to gather it in! Today, Tandderwen is a thriving bakery and grocery store which has successfully expanded over the last few years under the local ownership of Rachel Hughes, providing a valuable and popular service to visitors and locals alike. Much of the produce is locally sourced and baked on the premises.

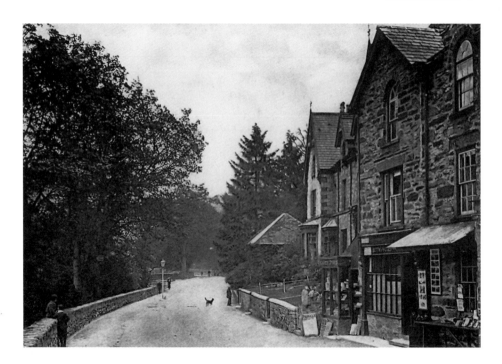

Old Post Office

This quiet scene on a traffic-free Holyhead Road captures the mood of the age. This is the golden age of the picture postcard and many cards can be seen on display outside the post office. Next door is a general store selling a variety of goods. A solitary gas lamp is the only illumination in this part of the street. Behind the wall on the left is the River Llugwy and the Royal Oak hotel is hidden behind the trees on the right. The outdoor shop below, for sale at the time of publishing is one of many such shops in Betws today.

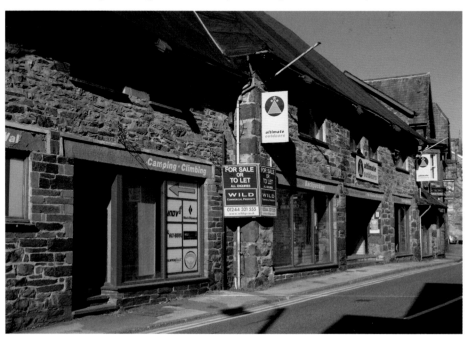

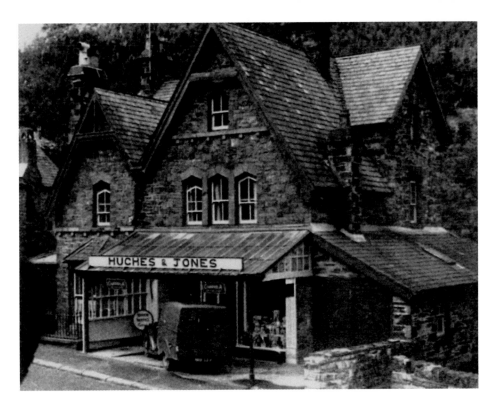

Hughes & Jones

Hughes & Jones was a typical small village shop situated on the Holyhead Road which sold all kinds of items as displayed in the window. For a small shop it has a large veranda which, as well as giving shelter for browsing customers, provided a useful parking space for the van. Notice the typical product advertising of the day. The building is now occupied by Hawkshead which is one of the many shops in Betws that sells outdoor and sporting clothing.

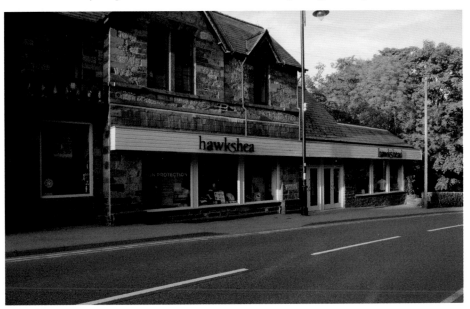

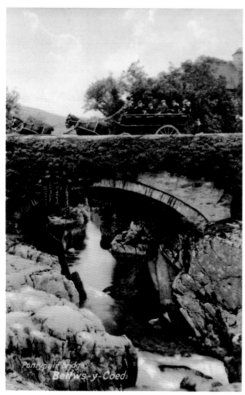

Pont-y-Pair I

The river Llugwy flows down from the mountains of Snowdonia through Capel Curig to Betws and is virtually followed by the A5 road. The Llugwy was the first river to be bridged and the bridge at Pont-y-Pair is thought to have been built in 1500. It provided a safer way for travellers to reach the coast as they were nervous of using the ferry at Conwy after an accident in 1808. Soon after the bridge, the Llugwy joins the Conwy at a point outside the village. The old picture dates from the mid-nineteenth century.

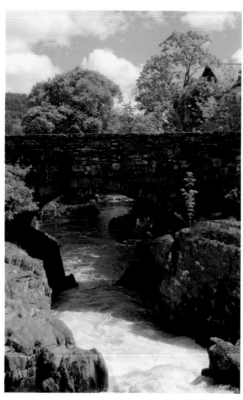

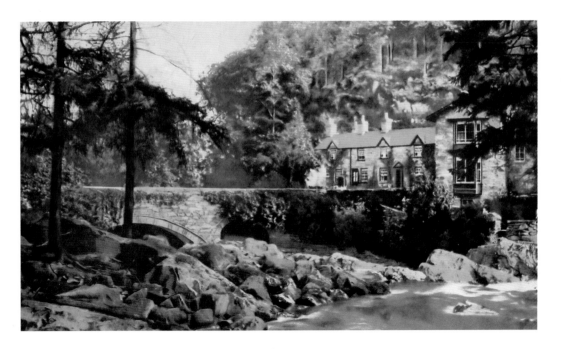

Pont-y-Pair II

Pont-y-Pair was built by stonemason Hywel Saer Maen whose home was in Bala. He must have been very competent to have been called to travel that distance but the challenge of the work was great. The meaning of Pont-y-Pair is usually interpreted as 'bridge over the cauldron' because that is the meaning of the Welsh 'pair'. However it could refer to the fact that this bridge was once used by the miners on their way to work. This very scenic location makes it popular with photographers and also a pleasant setting for picnic.

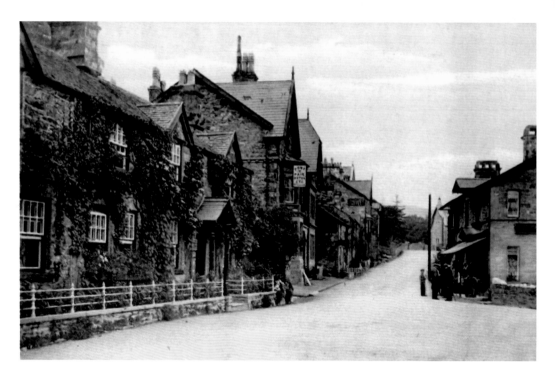

Pont-y-Pair Inn

The Pont-y-Pair, originally a coaching inn situated opposite the bridge of the same name has long been a popular stopping point for travellers. Many would have stopped here when the London to Holyhead coaches were diverted to run via Pont-yr-Afanc, Pont-y-Pair and Trefriw. This avoided them having to make the often dangerous ferry crossing at Conwy. Pont-y-Pair has continued to be a very popular local hostelry into modern times and also caters for visitors in one of the most attractive parts of the village.

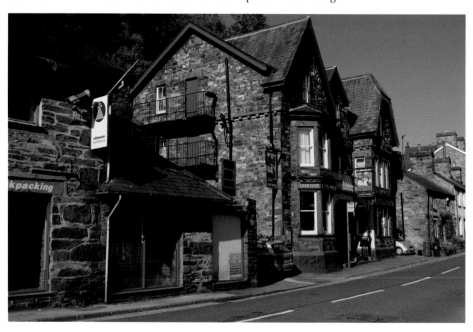

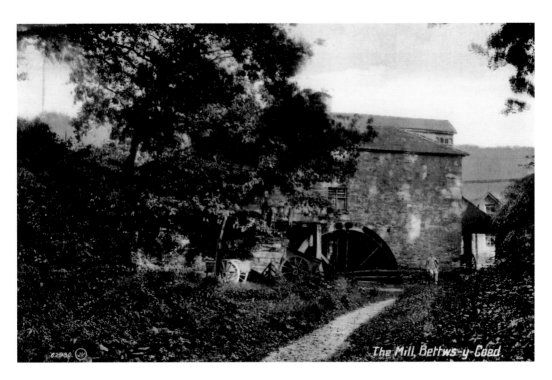

The Mill, Bettws-y-Coed

The Mill

Before the coming of electricity, mills were a vital part of every community and Betws-y-Coed was no exception. It was this mill that gave the name Pentre Felin (Village of the Mill) to this part of Betws and subsequently to Mill Street. Notice in the picture above the wheel of an old vehicle can be seen through the arch and behind it one of the houses in Mill Street. Little of the original building remains but part of it can be seen in the picture below.

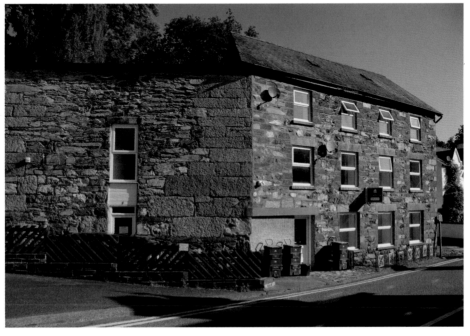

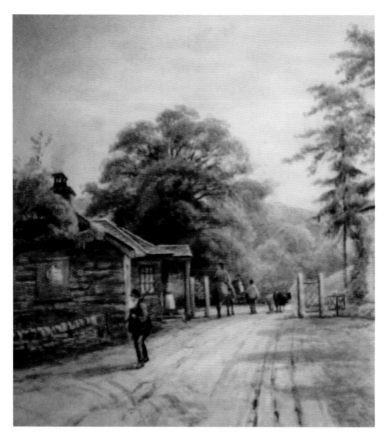

The Toll Gate

Toll gates were common on the newly built roads in the nineteenth century and often resulted in riots in some parts of Wales. Some of the old toll houses remain. Above is a picture, probably from the 1820s of a toll gate in Betws, situated near Pont-y-Pair. This was some time before the guest houses and other buildings on the A5 were built and gives a very rural appearance. The scene today at the same location looks totally different.

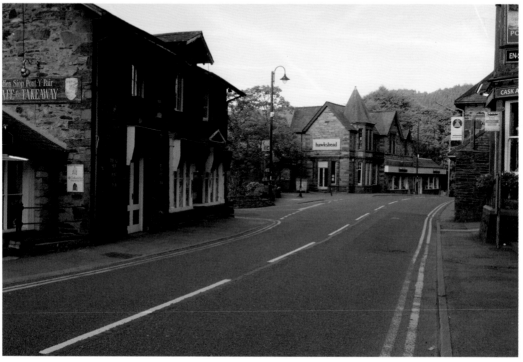

The Ancaster

The Ancaster on the main A5 road takes its name from the Ancaster Estate, local landowners. In the old picture it was a guest house and the words on the photo 'The Ancaster – betwixt hill and river' are clearly an advertising phrase. The modern picture shows the Ancaster as Rohan outdoor sports shop. Next door is Caffi Caban-y-Pair. This building was once a hairdresser's but it became a milk bar in the 1950s and soon grew in popularity. In 1990 it became Caffi Caban-y-Pair and remains a popular catering establishment.

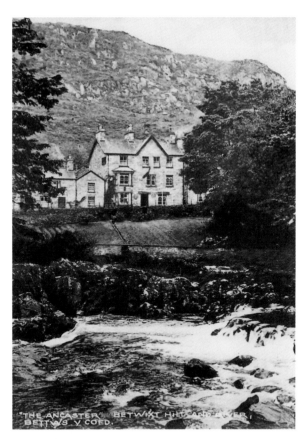

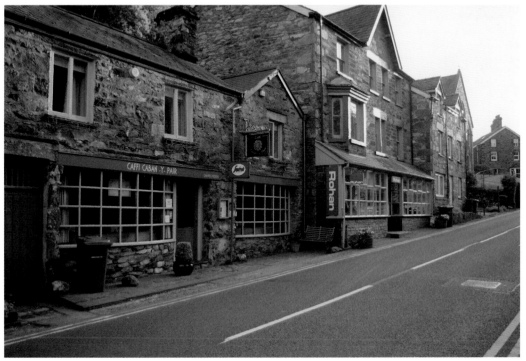

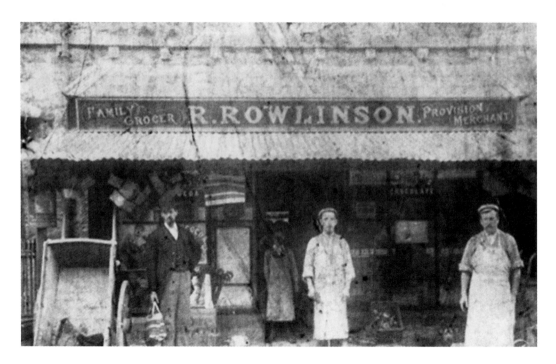

Rowlinsons

Long before the age of supermarkets, all communities, both large and small had many grocers and general stores which sold almost everything. According to an old saying, they sold everything 'from a needle to an anchor'. Even if the saying is somewhat exaggerated, people bought most of their daily needs from such shops. This is a typical posed photograph with the staff standing outside. Notice the cart outside the shop which would have been used for delivering the produce. The same location today is a modern shop selling outdoor sports clothing.

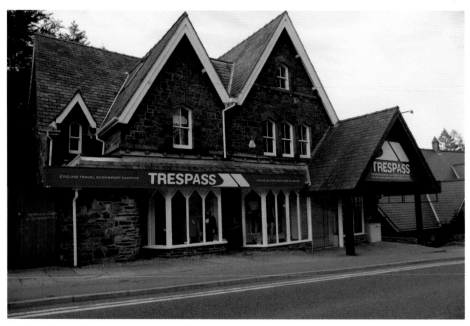

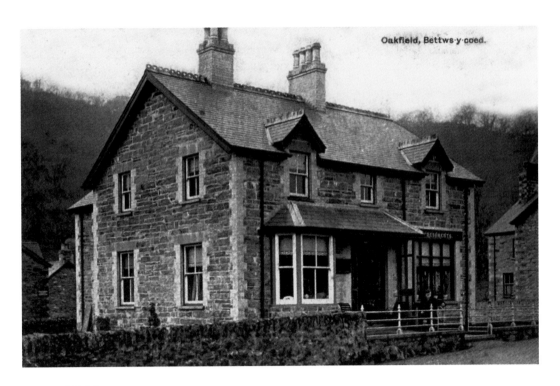

Oakfield, Bettws-y-coed.

Oakfield

Few buildings on the main road do not offer some kind of service to the traveller as passing trade along this road is considerable. This is very much true of Oakfield. The building, conveniently situated on the A5, has had many occupants in its time. It was originally a café but when the Miners' Arms pub in Mill Street closed, Oakfield became a pub and took the name Miners' Arms. Later it reverted to being a café. Oakfield has recently been extended and refurbished and is now a popular bed & breakfast establishment.

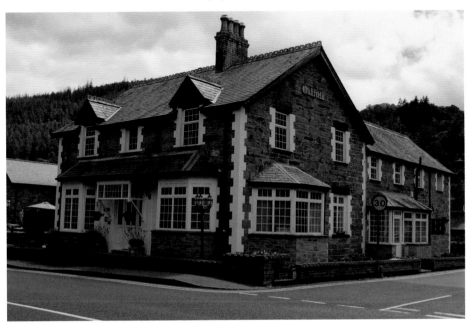

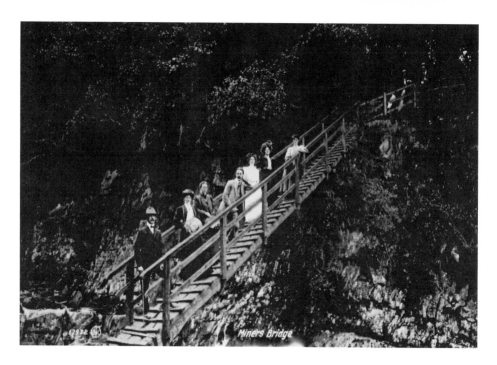

Miners' Bridge

At one time there were many mines and quarries in the area, long before it became a tourist attraction. To reach the mines it was necessary for the miners to cross the River Llugwy which was no easy task. The only safe way to reach the mines was to walk round to Pont-y-Pair and cross the river there. The only alternative was to scramble over dangerous rocks and try to cross the river on stepping stones. To make their task easier the miners built a bridge. The people on the bridge are tourists, in typical Victorian fashion, posing for a photograph. The mines have long since gone but the bridge remains a tourist attraction.

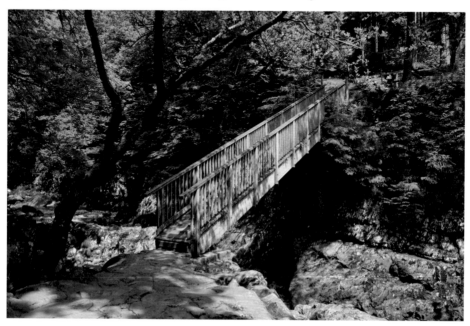

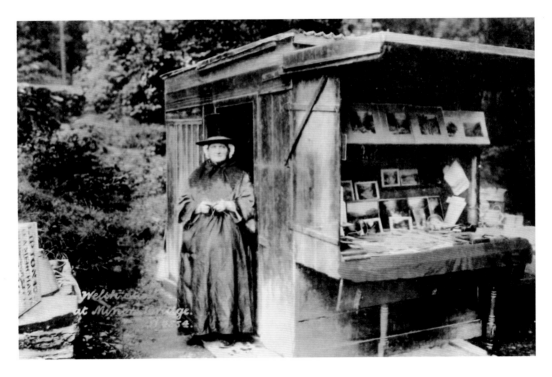

Miners' Bridge Gift Shop

From the early days, local people took the opportunity of providing facilities for tourists in the most remote locations. The lady in traditional Welsh costume had set up her stall in the woodland near the Miners' Bridge for the many tourists who visited that attraction. This is no more than a mile from the centre of the village and although the location appears remote, it was just a short walk from Pentre Du, the western part of Betws. The stall has long since gone but the woodland remains and still looks remote.

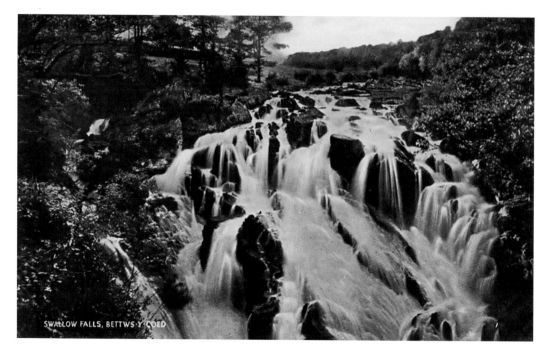

SWALLOW FALLS, BETTWS-Y-COED

Swallow Falls

This famous waterfall on the river Llugwy is visited by thousands of tourists every year. It acquired its English name as the result of a linguistic error. The Welsh name is Rhaeadr Ewynnol, meaning 'foaming falls'. Somehow 'Ewynnol' became changed to 'Y Wennol' which means 'the swallow' so it was translated into English as the 'Swallow Falls'. The incorrect name stuck and it has been known as Swallow Falls ever since. The local landowner gave the falls to Betws-y-Coed council in 1913. They charged people to see it and the proceeds paid for the installation of electricity to the village. There is a legend that the spirit of Sir John Wynn, sixteenth/seventeenth-century landlord lies beneath the falls.

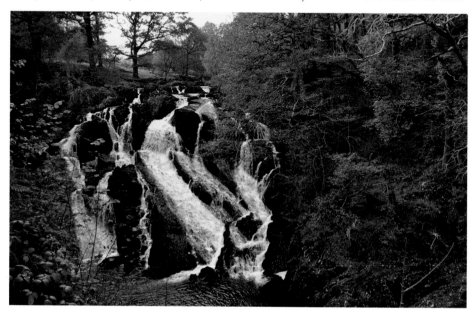

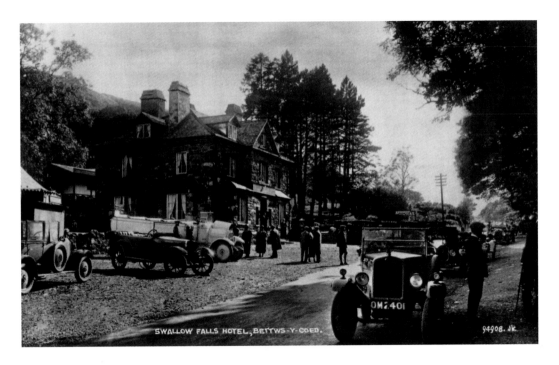

SWALLOW FALLS HOTEL., BETTWS-Y-COED. 94908. Jk

Swallow Falls Hotel

This fascinating picture, probably dating from the 1920s or 1930s shows a collection of old vehicles. It seems unlikely that such a large number of cars would have arrived 'by chance' to park here, but rather that this is some kind of a car enthusiasts' event. Such events used to be held when the cars travelled here from Chester. They would have pre-booked a meal for themselves at the hotel after seeing the falls which remain a popular stopping point for today's motorists and similar vintage car events have met at this hotel in recent times.

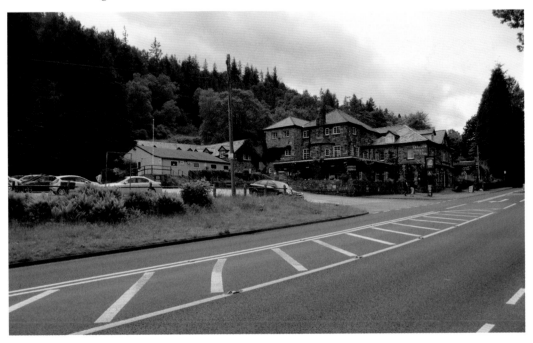

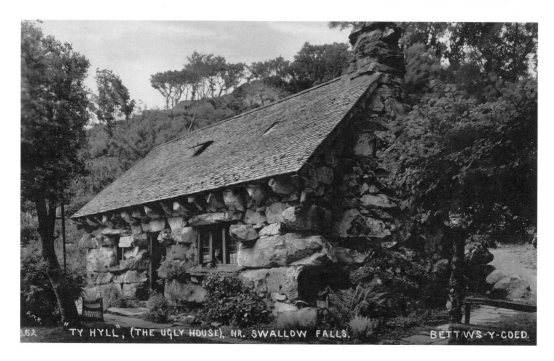

"TY HYLL", (THE UGLY HOUSE), NR. SWALLOW FALLS. BETTWS-Y-COED.

Tŷ Hyll (The Ugly House)

This popular attraction lies about three miles from Betws-y-Coed on the A5 towards Capel Curig. Despite its name, it is thought by many to be an attractive old house. It is said that it may have been a *tŷ un nos*, meaning that anyone who built a house on common land between sunset and sunrise could claim legal ownership. In reality, this is a folk tale that has its place in legend. The house, until recently occupied by the National Park Society, is now a popular tea room and works for the preservation of bees and production of honey.

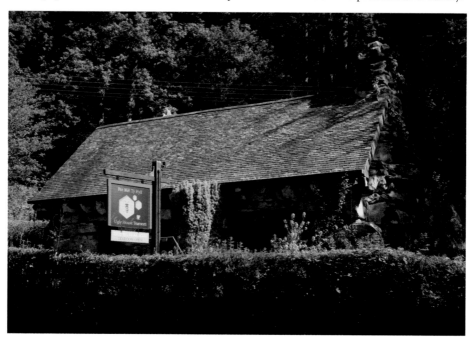

Llanrwst

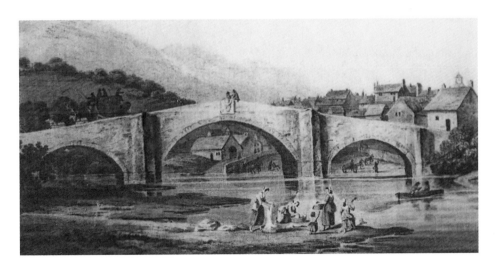

Pont Fawr (Llanrwst Bridge)

The bridge was built in 1636 to replace a previous one. Tradition has it that it was designed by the famous architect Inigo Jones. The day it was opened the central arch collapsed because the locking stones had been placed upside down. A local story says that this was because the workmen were paid in mead rather than in cash. During the rebuilding they were only allowed to drink buttermilk! The bridge has become symbolic of Llanrwst and features on the road signs welcoming motorists to the town. Notice how, in the old days, people did their washing in the river.

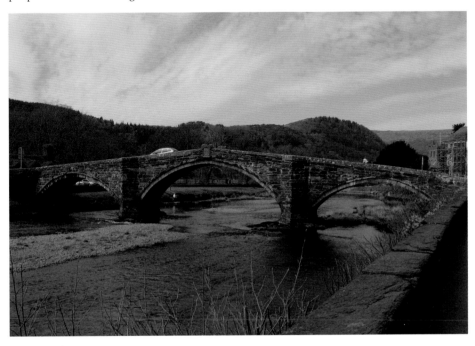

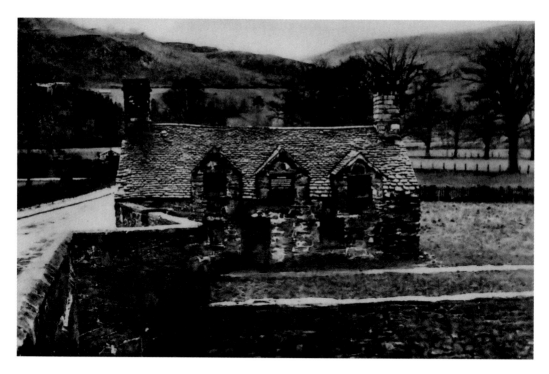

Tu Hwnt i'r Bont

This attractive building was built about 1480 as a private residence but later was used as a courthouse. The name, which means 'beyond the bridge' is interesting as the building predates the bridge by over 150 years, because it refers to a previous bridge. Over the centuries, the building experienced deterioration and restoration many times. It is now owned by the National Trust and is a very popular café serving traditional Welsh afternoon teas made with local recipes, traditional bara brith being their speciality. No visit to Wales is complete without eating some bara brith.

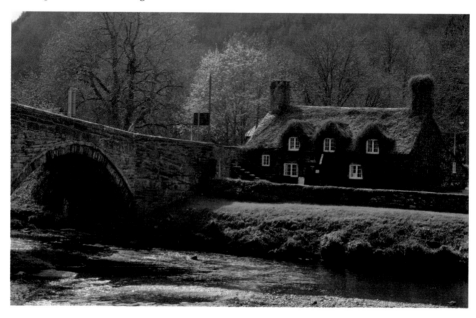

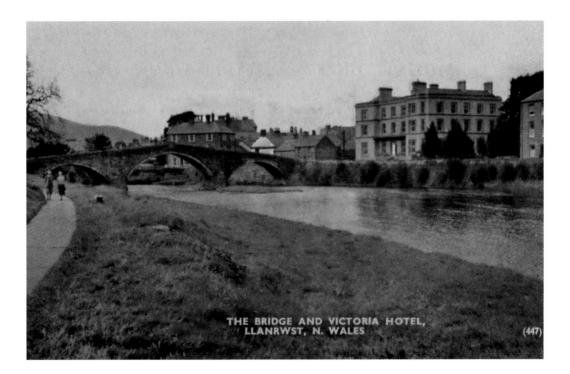

THE BRIDGE AND VICTORIA HOTEL, LLANRWST, N. WALES (447)

Victoria Hotel I

The Victoria, the large building on the right, was one of the main landmarks in Llanrwst. This hotel faced people who entered the town by crossing the bridge. It was built in the nineteenth century and soon became very popular with visitors to the town as it offered views of the bridge and river. By the late twentieth century patronage of the hotel had declined and it remained empty for a number of years. It was demolished in 1999 after being declared unsafe. Except that the Victoria has gone, there is little change in the modern picture.

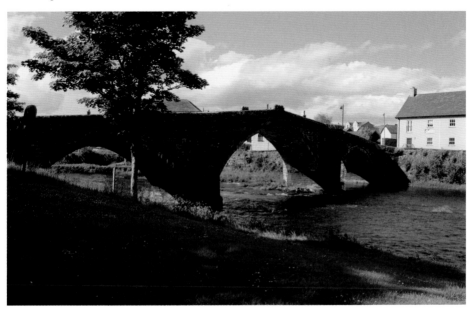

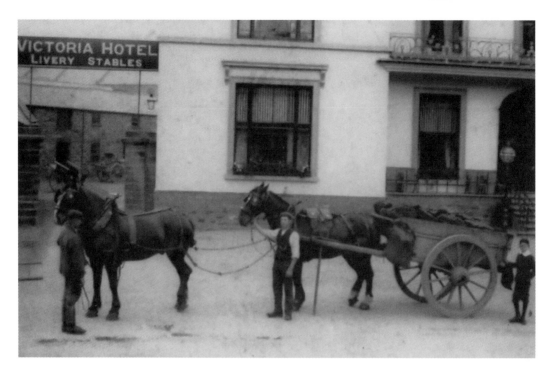

Victoria Hotel II

The Victoria Hotel was built in 1860 as it was expected that the planned railway to Llanrwst would terminate near the bridge and a station would be located there. As it happened, the railway which was built three years later took a different route through a cutting and is mostly hidden from the town and the station was located about a mile to the north of the bridge. It was horse transport that was used to take people and goods to and from the Victoria. Notice the livery stables which were an important feature of all hotels in this period. The hotel was demolished in 1999 and replaced by a block of apartments.

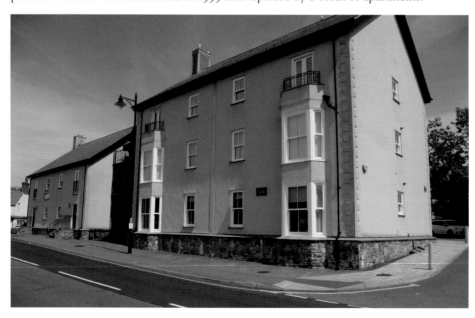

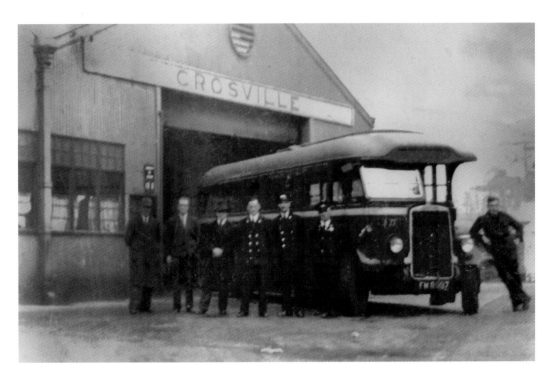

Crosville Bus Depot

Crosville, which ran its first bus in Chester in 1911, expanded into Wales after the First World War, opened a depot in Betws Road, Llanrwst in 1929. The depot provided many market day services to outlying small villages. The vehicle pictured is a Leyland bus purchased new by Crosville in 1935. By the late 1960s many bus services were withdrawn or curtailed and Crosville let one half of their Llanrwst depot to Jones Bros Garage who occupied premises next door. The bus depot continued as an outstation to Llandudno Junction until the first decade of the twenty-first century. Both sides of the building are now occupied by the Gwydyr Garage.

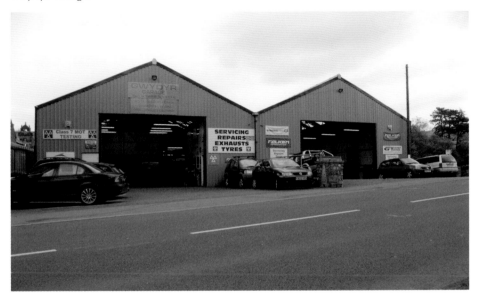

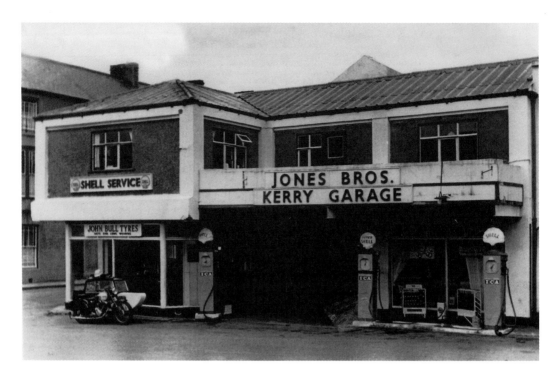

Jones Bros Garage

Jones Bros, which was owned by a Llanrwst family, was a well-established North Wales company which had two garages in Llanrwst and one in Abergele. This garage on Betws Road for many years, offered a vehicle sales service as well as the usual repairs. In the late 1960s Jones Brothers took over half of the Crosville depot next door as they needed extra space to expand their business. Jones Bros occupied the site until the late twentieth century, when the building was demolished and there is now a block of flats on the site.

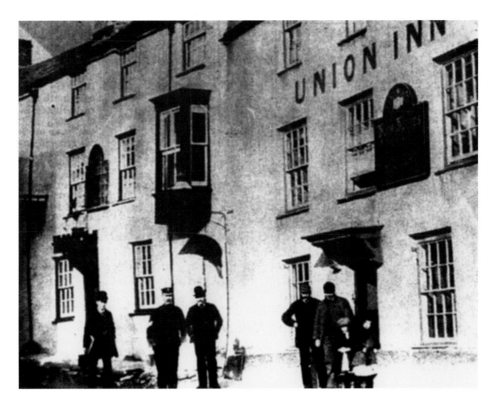

Pickwick's

This building began its life as the Union Tavern at the end of the sixteenth century. This was the time when the town increased in prosperity. The Tavern enjoyed an even more prosperous business after 1780 when the London to Holyhead coaches were routed through Llanrwst. By the early nineteenth century it was basically a public house and later became known as Cornucopia. New owners took over in 1993 and it became Pickwick's Antique Shop and Café. During restoration a medieval well was discovered which makes it an interesting place to visit.

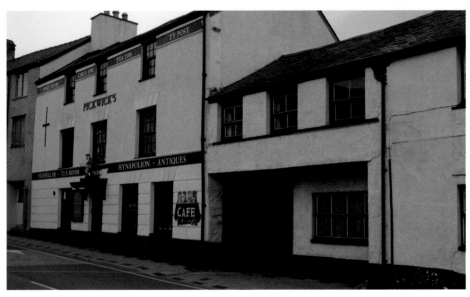

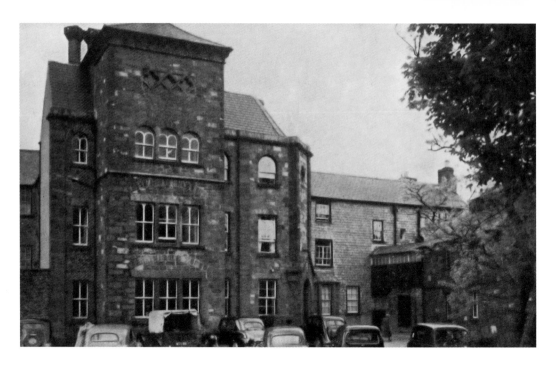

Eagles Hotel

The Eagles Hotel is a prominent building in the centre of Llanrwst. It originates from the eighteenth century but was rebuilt and enlarged in the mid-nineteenth century at a time of rapid growth in tourism. The rebuild included the distinctive Italianate tower. The name is derived from the three eagles on the coat of arms of the Wynn family, prominent landowners in Tudor and Stuart times. The Eagles remains popular with both townspeople and tourists. Its ample capacity makes it ideal for catering for large events. The building has not changed much since the 1950s picture except that the cars give away the age in both pictures.

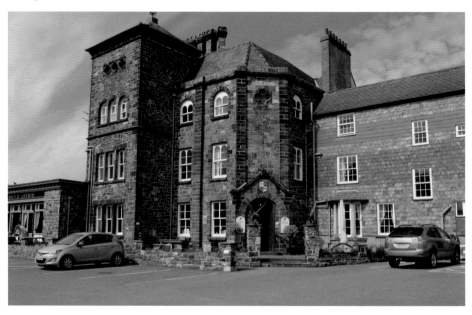

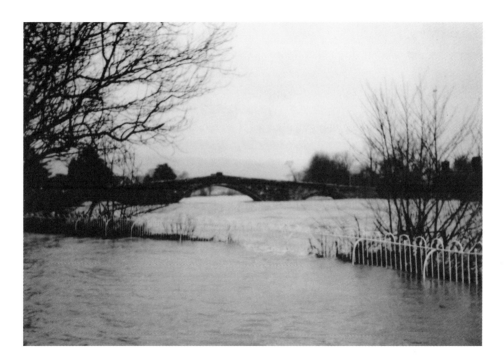

Floods

The River Conwy, which is tidal up to about one mile south of Llanrwst is subject to flooding during heavy rain and exceptional high tides. When the water is almost to the top of the bridge it means that the road out of the town, known as the Gwydir stretch (seen on the right) is impassable and traffic from Trefriw to Llanrwst has to be diverted via Betws-y-Coed. Work has since been done and much money spent on alleviating the floods which are much rarer than they used to be. Both of these photographs were taken from the car park of the Eagles Hotel.

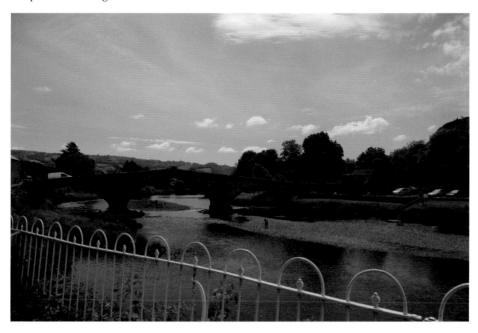

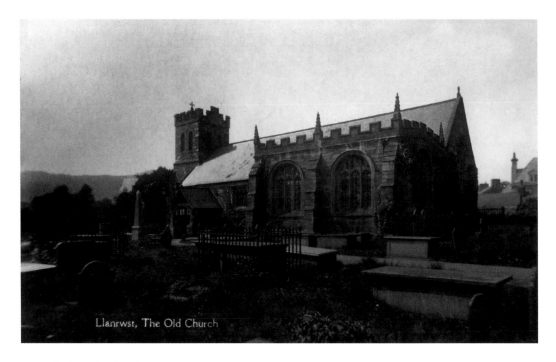

Llanrwst, The Old Church

St Grwst's Church

The Celtic St Grwst founded a church here in the sixth century and so gave the town its name. The original (wooden) church was at the site where Seion Chapel now stands. The present St Grwst's church was built in 1470 on its riverside site to replace a previous church built in 1170. It was enlarged in 1884 at which time the tower was built. The church continues as an active place of worship. The church's most interesting feature is the fifteenth-century rood screen which has retained its loft. It may have been brought from Maenan Abbey when the monastery there was dissolved in 1537. Adjoining the church is the Gwydir Chapel which contains the coffin of Llewelyn the Great.

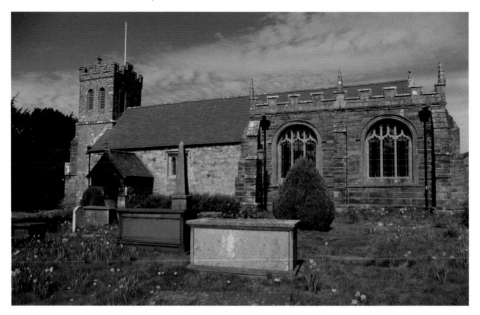

The Almshouses

The twelve almshouses forming a terrace on Tan-yr-Eglwys between the Square and the Church were built by Sir John Wynn in 1610 for elderly poor people. They functioned as such until 1976 after which they lay empty for twenty years. They reopened in 2002 as a local history museum containing interesting exhibits from Llanrwst and the surrounding rural area. The museum closed in 2011 and the buildings remained empty for two years. In 2013 they were taken over by Llanrwst Town Council as a council chamber.

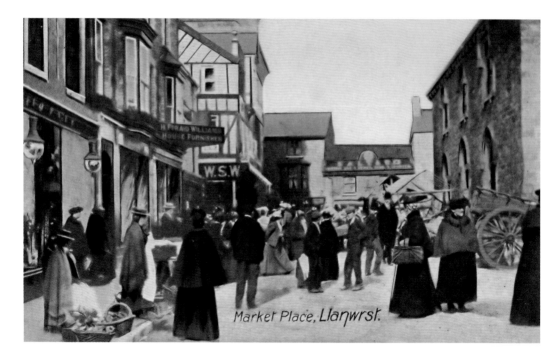

Market Place, Llanwrst.

Market Day I

Llanrwst has been a market town since the thirteenth century, although twice in its history the Square was laid to waste, at the time of Owain Glyndwr and at the Wars of The Roses, after which the town regained peace and prosperity. In the fifteenth century a market hall was built and two hundred years later it was rebuilt as a town hall. Following a fire it was rebuilt again in the eighteenth century as a two-storey building with an elaborate clock. This building was demolished in 1964 and some parts of the old clock were returned to the Square as part of the new clock tower built in 2002

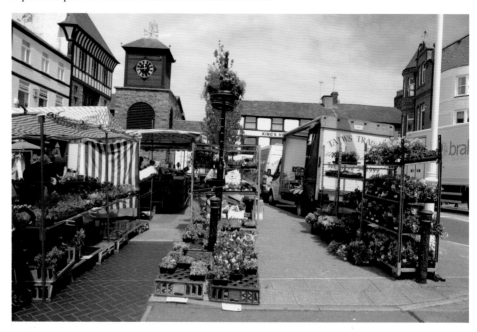

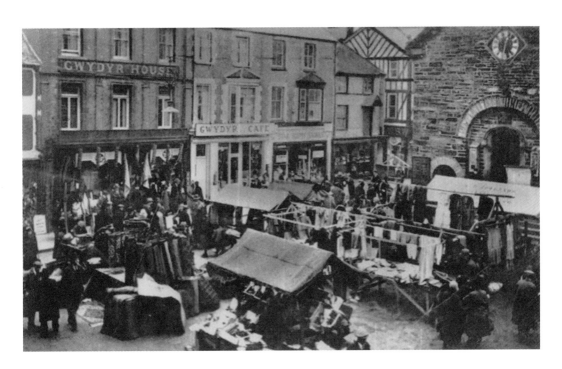

Market Day II

In this late 1940s/early 1950s busy market-day picture, most people are chatting with each other rather than buying goods. This is no surprise as market day was when people caught up with the local news. The passage at the side of WSW was once known as Steam Packet Lane as it led to the river from where very small boats went to Trefriw from where the goods were transferred to larger boats which went to Conwy and beyond. It is easy to imagine why this narrow passage was sometimes known as 'Smugglers Lane'. The new picture is a market day in 2015.

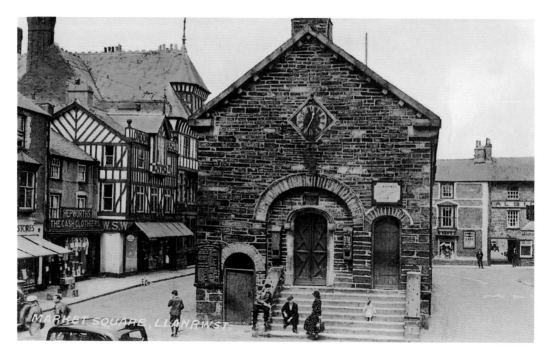

London House

W. S. Williams clothes store had a fascinating way of taking customer payments. The sales assistant would put the payment in a small wooden pot and attach it to a wire and propel it to a cashier sitting on a balcony at a high level. The cashier would take out the cash, issue a hand-written receipt and send the pot back to the sales assistant by the same method. When the store was busy, there could be several wooden pots 'flying' around at the same time. The Hepworths store next door was a branch of the well-known men's clothes shop.

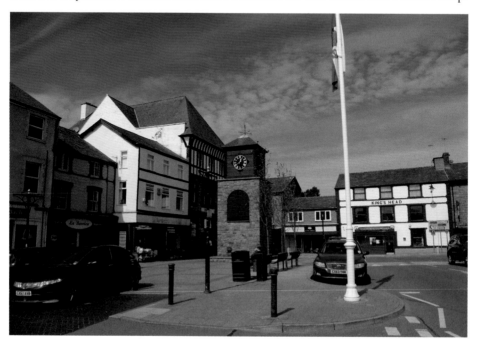

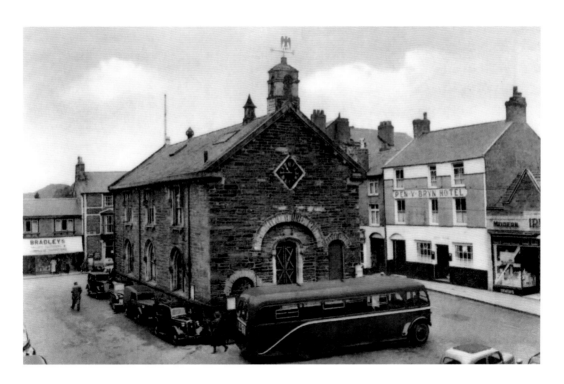

Pen-y-Bryn Hotel

This seventeenth-century coaching inn has been in continuous use as a public house since it was built. The arched entrance on the left-hand side of the building is a reminder of the days when horses pulled drays of beer kegs into the back yard. It stands at the highest point in the square as its name indicates. It is the only feature common to the two pictures. The town hall has gone. Bradleys (clothes shop) and Irwins (grocer) were branches of companies that had many shops in North Wales. Spar now occupies the old Irwins site. The Crosville bus in the 1950s picture is waiting to depart for Llandudno.

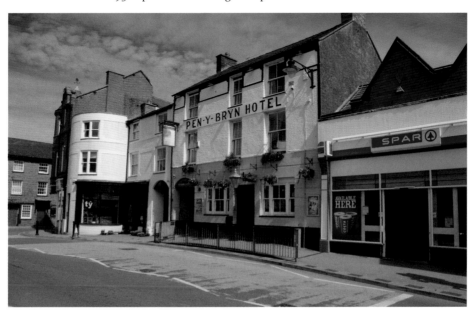

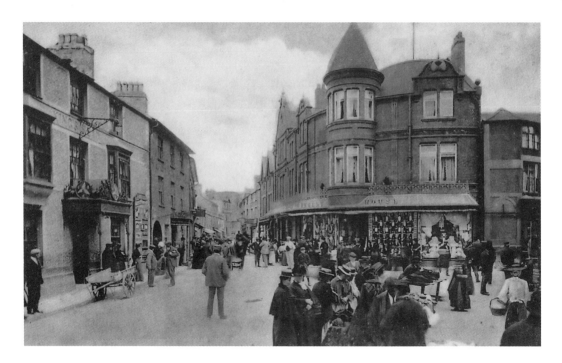

Regent House

This large three-storey building at the corner of Denbigh Street and the square dates from the eighteenth century. The building was rebuilt and enlarged with the distinctive curved front in 1902 and was at the time the tallest building in the town. It was for many years a draper's shop owned by William John Williams whose son Richard went to the USA in 1906. He returned to Llanrwst in 1933 and became a builder. He named one row of houses that he built, Regent Park. Today, Regent House is occupied by Ty Asha Balti House, a takeaway and restaurant.

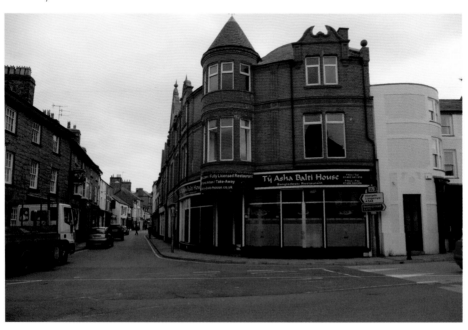

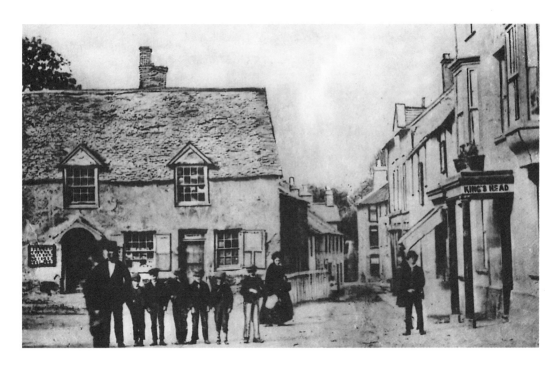

King's Head

This building was the birthplace of Llanrwst harp maker John Richards in 1711 from where he ran his harp-making business, the triple harp being his speciality. Some of his customers were royalty and it is probable that a harp in the Victoria & Albert Museum in London was made by him. After a short time as a public house, the King's Head became a temperance hotel in 1896. Such places grew up at the time in order to provide a social meeting place without alcohol. It later reverted to being a pub and then, for many years, was the Llanrwst home of the Royal British Legion Club. It is now an independent club known as Clwb Llanrwst.

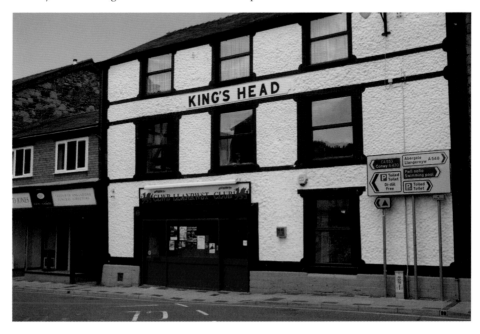

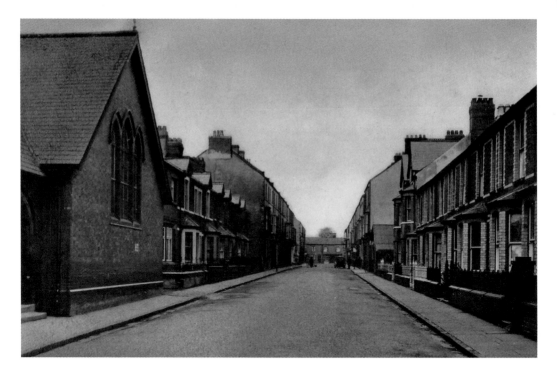

Watling Street

The name Watling Street is interesting but has its origins far from Llanrwst. The Romans improved the original Watling Street from an old road and extended it to run from Dover to Wroxeter in Shropshire. Much of the present A5 road follows the route of Watling Street and the only connection with Llanrwst is that the A5 runs four miles south of the town. In both pictures Watling Street has a mixture of commercial and residential property. The large building on the left is the former Church House, now used as a community hall.

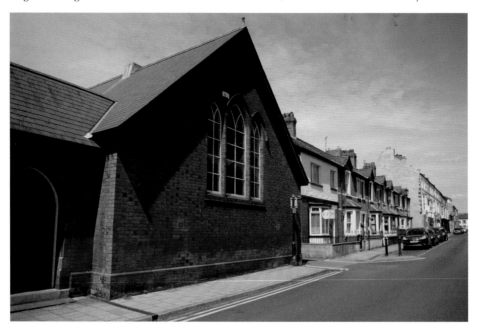

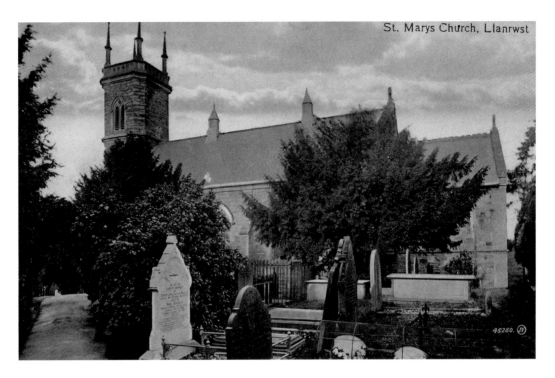

St Mary's Church

From ancient times most the residents of Llanrwst were native Welsh speakers and St Grwst's church conducted almost all of its services in the Welsh language. However, St Mary's was built in 1842 to cater for the increasing number of English speaking visitors and residents. It was enlarged in 1875 as the population of the town continued to grow. It continued to be used well into the twentieth century but when it was realised that the parish church of St Grwst could accommodate the Welsh and English congregations, St Mary's closed in 1970. It was demolished in 1984.

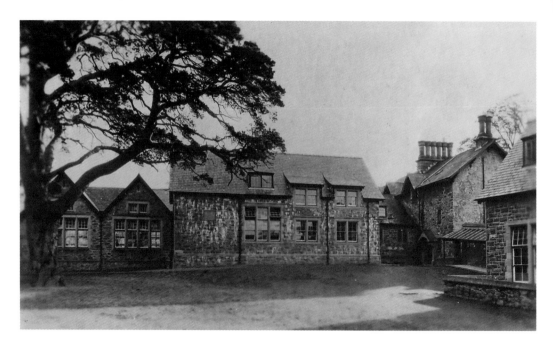

Llanrwst Grammar School

Llanrwst Grammar School founded by Sir John Wynn of Gwydir was built as long ago as 1610 and it was one of the first grammar schools to be set up anywhere in Wales. Much of the cost of building it was probably donated by John Williams of Dolwyddelan. The building remained in use until recently as Ysgol Dyffryn Conwy. Some of the original buildings remain. When the school moved to a new site in 2010/11, the building was redeveloped as a surgery and a residential and social centre for elderly people.

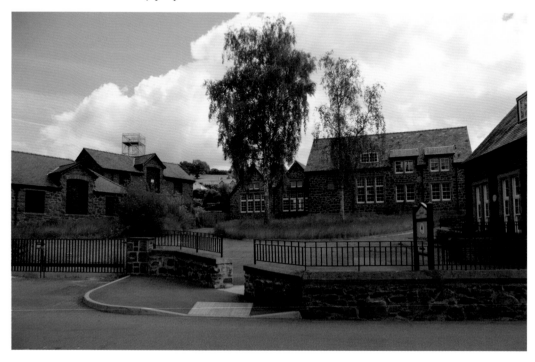

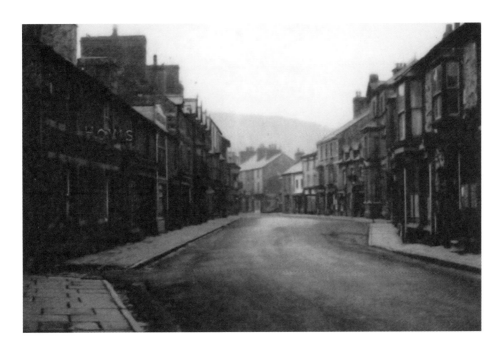

Scilicorn's Bakery

This building dates from the beginning of the eighteenth century and is thought to have been a bakery as far back as those days. It may have been what was known as a public bakery where poor people could buy bread at a reasonable price. Henry Skillicorn came to Llanrwst from the Isle of Man in the late nineteenth century and he and his wife, Jane, took over the shop which remained in their family until the 1950s when the Williams family took over. In the early 1970s, the Griffiths family bought the business and restored the Scillicorns' name. The bakery, which still uses a 100-year-old oven, remains popular to this day.

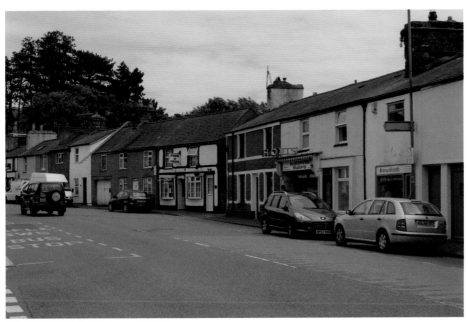

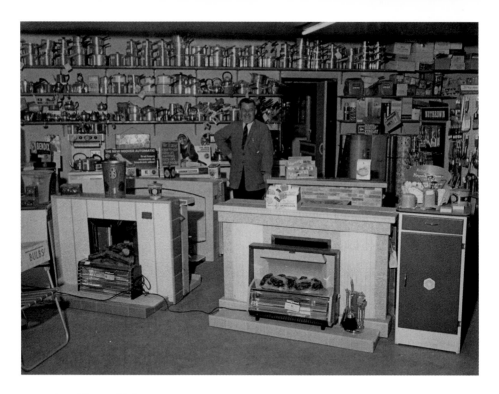

Jones & Bebb, Denbigh Street

Jones & Bebb was a well-established ironmonger and kitchen supply store for many years. It also served as a builders' merchant. It was very well stocked and customers were able to buy items there that were difficult or even impossible to obtain in many larger towns. They had premises in Watling Street and in Denbigh Street. This picture is of the Denbigh Street shop with the late Glyn Williams behind the counter in the late 1960s. In the early twenty-first century the store was taken over by C. L. Jones who still owns it today.

Scotland Street

This part of the town has been considerably redeveloped in recent years. Many of the old houses have been demolished and have been replaced with modern apartments. The area looks very different from what it did a few years ago. After the demolition of the old houses, a Kwik Save supermarket was built on the site which is occupied by the Co-op. Also a car park was provided. Although the area all around it has been demolished and redeveloped, Scotland Street chapel remains in its original location and is still in use.

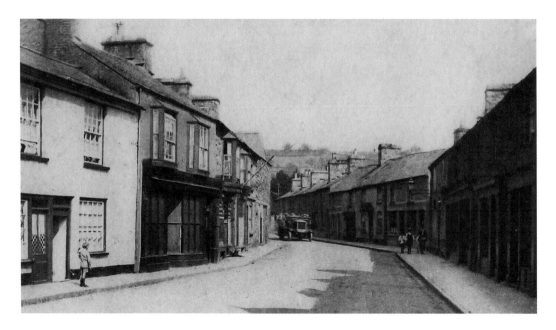

Bys a Bawd

This shop in Denbigh Street was formerly occupied by a grocery shop and a sweet shop being two separate concerns. William Berry took over the sweet shop in 1955 and it continued as a thriving business selling much local produce. In the 1980s the two shops were taken over by Arianwen Parry and her daughter as a Welsh bookshop and stationery shop as Bys a Bawd. The Welsh bookshop had previously been in Tan-y-Graig. Bys a Bawd was taken over by Dwynwen Berry (William's daughter) and continues to provide a useful service, particularly to the Welsh-speaking community.

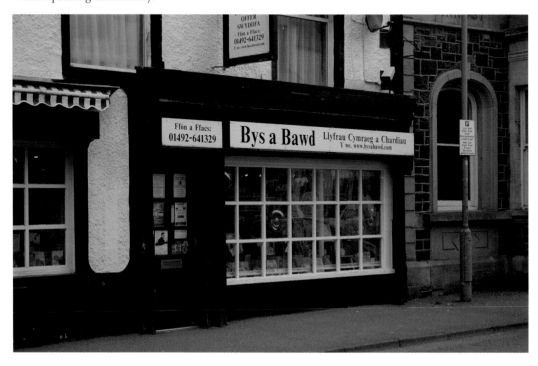

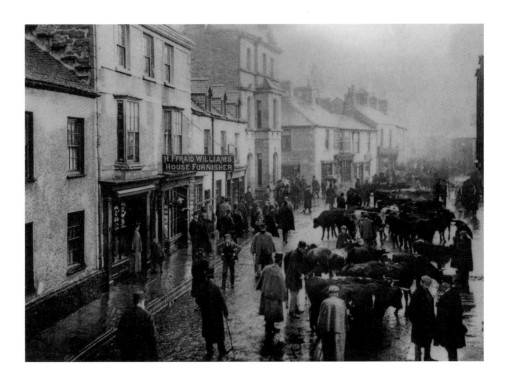

Street Cattle Market

In old times it was not unknown for livestock markets to take place in the street. At first glance this cattle market in Denbigh Street looks somewhat disorganised but a closer look shows how the cattle, with their buyers and sellers are on one side of the road and the spectators on the other. The cow that is trying to walk away looks rather bored at the proceedings. It is likely that the cattle and their owners had walked into town from nearby farms and would walk home in the same way. With today's motor traffic such a practice would be impossible and now livestock markets take place at dedicated sites, including one in Llanrwst, the beasts being transported by lorry.

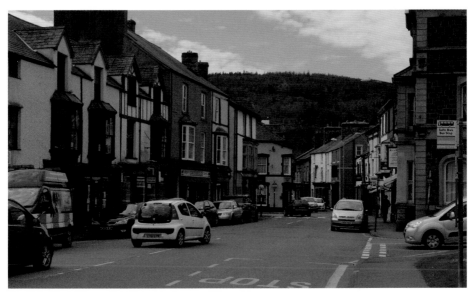

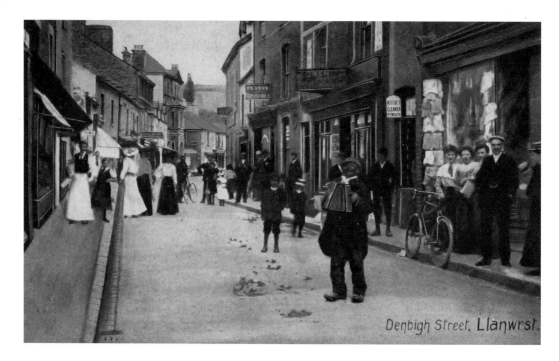

Denbigh Street

This photograph shows everyone in their best clothes and an accordion player looking as if he is enjoying himself. There is probably some sort of event taking place in Denbigh Street. Maybe the accordion player was trying to get a sing-song going or maybe he was just busking. This would be usual in those days. It is interesting to see the clothes shop displaying its wares outside the shop. J. Owen's provision shop is one of many such shops that existed at the time.

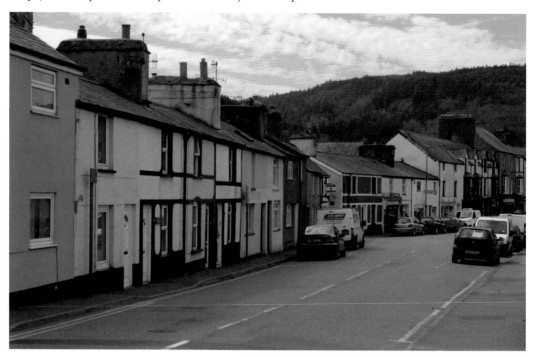

E. B. Jones

This store captures the spirit of its time, selling every food product. Many staff were required as much of the food was sold loose. Butter was cut from a large slab, bacon was sliced to order. Sugar was weighed from a large container into small bags. Various kinds of loose teas were available which were blended according to the customer's request. No one had heard of tea bags. Even biscuits were sold loose, the broken ones at a reduced price. E. B. Jones was a company that had a store in every town and even in many villages in North Wales. The building is now occupied by Snowdonia Antiques so it still retains a link with the past.

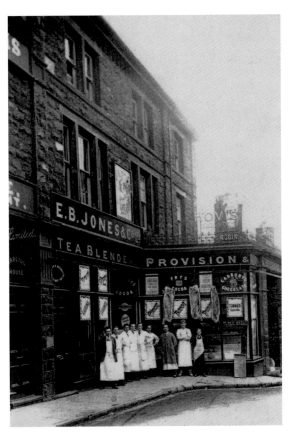

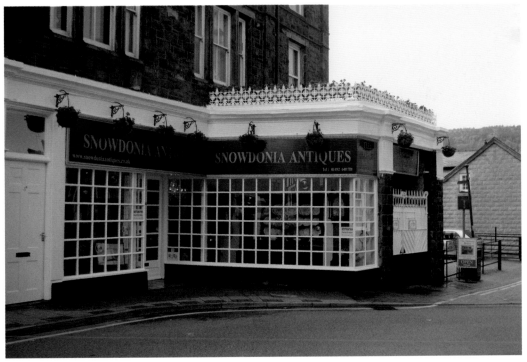

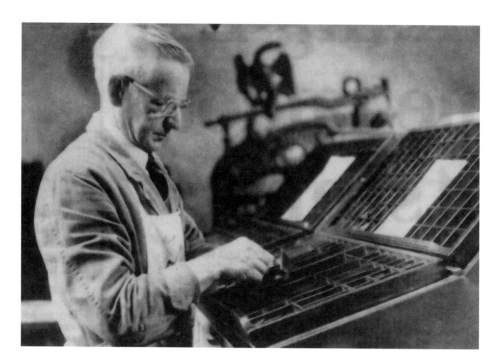

Printing

Ted Jennings was one the best-known characters of Llanrwst and is seen here at his printing press in Willow Street. He began work for Lloyd Roberts printers when he left school and took over the company in 1936. He continued to work until he was seventy-five. For Ted, who worked in the old style of printing, accuracy was of the utmost importance and many people in the town experienced the high standard of his work. This picture has been loaned by Pat Rowley, his daughter, who has made many of the pictures in her collection available for this book. The premises no longer exist and houses now occupy the street. The old tannery in the distance is now a popular restaurant.

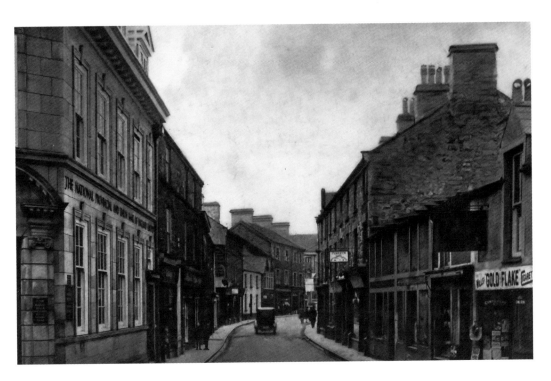

Old Bank

In Victorian times, banks built impressive buildings for themselves even in small market towns like Llanrwst. The early twentieth-century picture of Station Road shows the National Provincial Bank. Notice the carved logo over the door as well as the 'National Provincial...' letters taking up the entire length of the building. By the 1960s it had become the Natwest bank but it closed in 2015. The newsagent/tobacconist opposite the bank has become apartments and the old Penrhyn Café has retained its catering status as the building is now a milk bar.

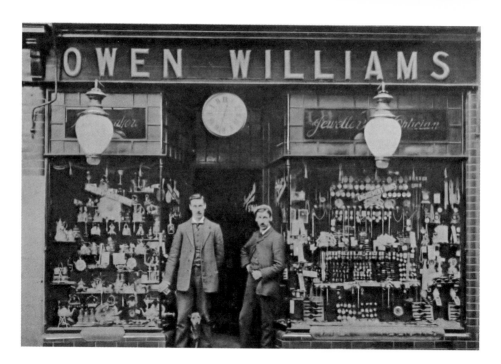

Crown Buildings

This early twentieth-century picture of Owen Williams, jeweller, watchmaker and optician shows a substantial range of items. It is difficult to believe today that clocks and watches could be made to order from a local jeweller, but in those days people rarely travelled out of their own locality. This was no surprise considering Llanrwst's heritage as a clock-making town. The staff (including dog) standing outside was a feature of most shops and the large clock a usual feature of jewellers shops. Today the building is occupied by an optician but no longer sells clocks and jewellery.

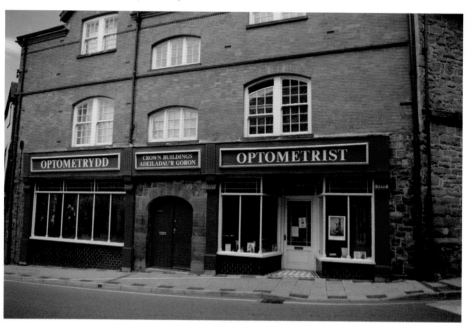

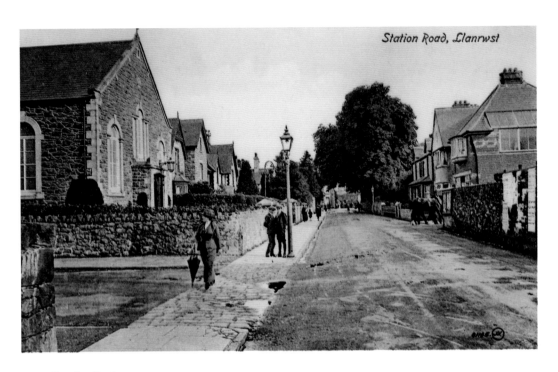

Station Road, Llanrwst

Sunday Best

The archive picture above shows a typical Llanrwst Sunday in the early twentieth century. Everyone is wearing their Sunday best as was traditional in those days. The well-dressed lady is surely on her way home from chapel, her umbrella not only for shelter from possible rain but also a fashion accessory. The two young men standing by the gas lamp look rather bored and reluctant to be wearing suits. In the distance a number of families are making their way to or from chapel. The quiet modern picture is taken during a lull in the traffic on a summer weekday afternoon.

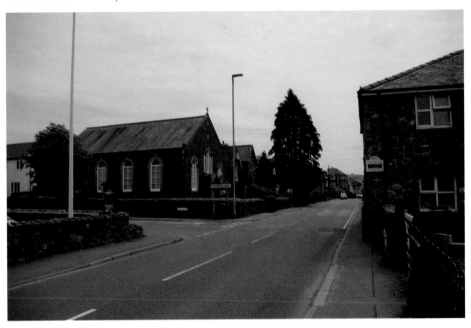

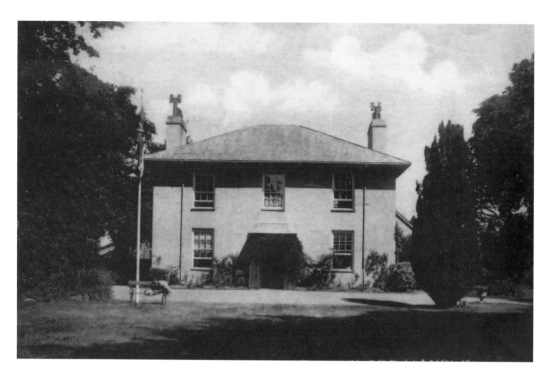

Plas-yn-Dre

Plas-yn-Dre was a manor house built in Station Road in the nineteenth century. It was demolished in the 1930s to make room for the new Luxor Cinema which was an ultra-modern cinema for its time. The Luxor closed in 1966 and Kwik Save supermarket took over the building until they moved into new premises in the town centre. The cinema building was demolished in 2004. The new building on the site, Glasdir was built in 2007 as a business and educational centre offering many facilities including the county library. The adjacent Police Station built on the site in 1963 is still there.

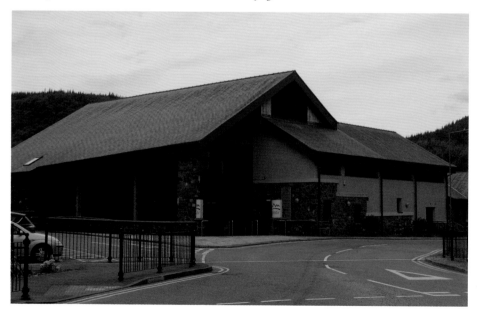

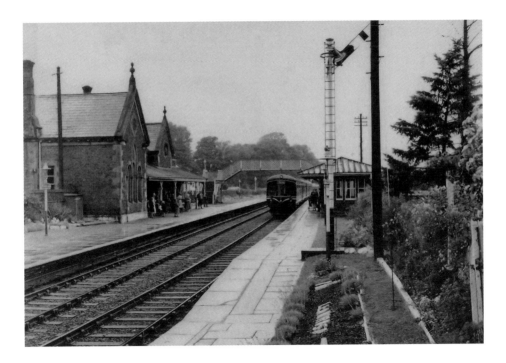

Railway Station I

The Conwy & Llanrwst Railway opened in 1863 providing a link from the main Chester & Holyhead Railway to the Conwy Valley. Llanrwst grew after the coming of the railway and the large station building for a while served as the headquarters of the company. In 1868 the line was extended to Betws-y-Coed and in 1879 to Blaenau Ffestiniog to capture a lucrative business in the slate trade. The picture shows a typical 1950s scene with the then new diesel unit at the station. In 1989 a new station was provided in a more central location. This station was named Llanrwst and the original station was retained and renamed 'North Llanrwst'.

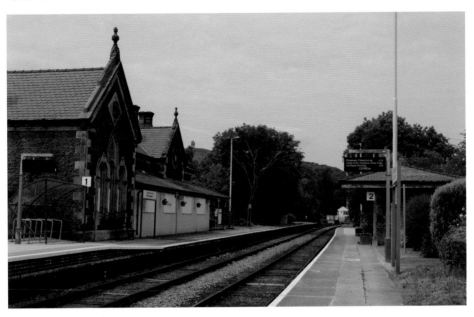

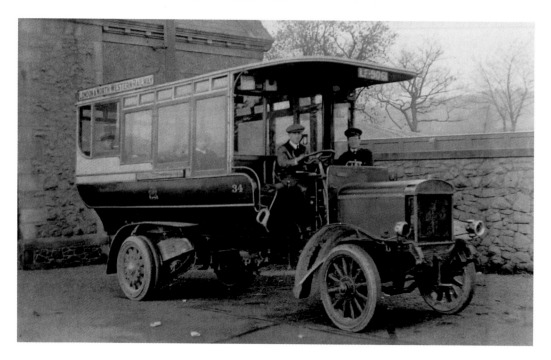

Railway Station II

The London & North Western Railway bus standing outside Llanrwst Station in the 1920s was waiting to take passengers from the train to outlying villages. The railway company ran these buses for two reasons, one to compete with other bus companies and two, to see if they could operate buses more economically than trains in rural areas. The station is now North Llanrwst and although no buses call there, it provides a useful parking space for train travellers as it is a more convenient location for motorists than the station in the town centre.

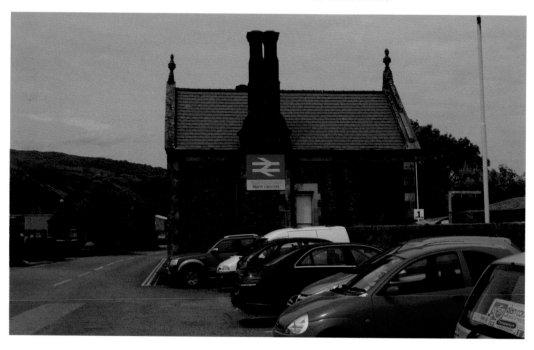

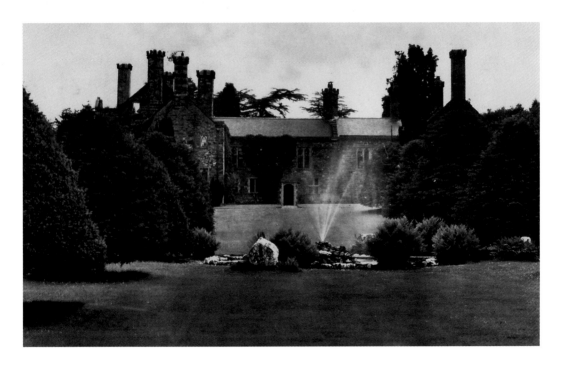

Gwydir Castle

It is thought that a fortification existed at this site as early as the sixth century but the first-known occupants were the Coetmor family in the fourteenth century. It was rebuilt in the fifteenth century by the Wynns, a prominent North Wales family at that time. It became their ancestral home and many significant people, including royalty, were associated with it. It was altered many times up to the nineteenth century, but by the early twentieth century it had fallen into disrepair and there was a disastrous fire in 1922. From the mid-twentieth century subsequent owners have restored it to its former splendour. Today it remains in private ownership but is open to the public during the summer.

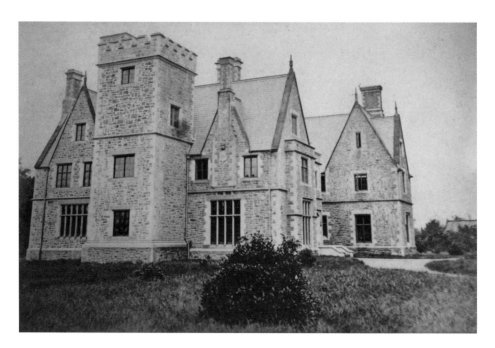

Maenan Abbey

When Edward I built the town and castle of Conwy he displaced the monks of Aberconwy Abbey up the valley to Maenan. They took with them the coffin of their patron, Llywelyn the Great. There they settled and Maenan became a place of importance. When the Abbey was dissolved, Llywelyn's coffin was taken to Llanrwst church where it remains to this day. Subsequently the Abbey was demolished and nothing, except perhaps for a few stones remains of it now. In later times a large private house was built on the site which subsequently has become the Maenan Abbey Hotel serving excellent meals to its customers in a peaceful setting which to the imaginative mind can bring back memories of monastic times.

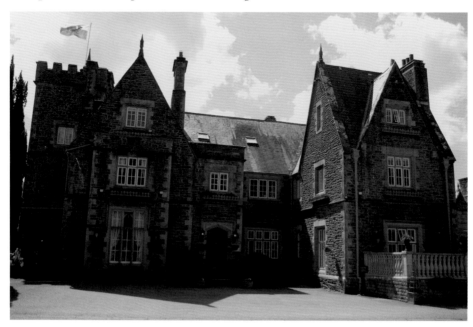

Trefriw

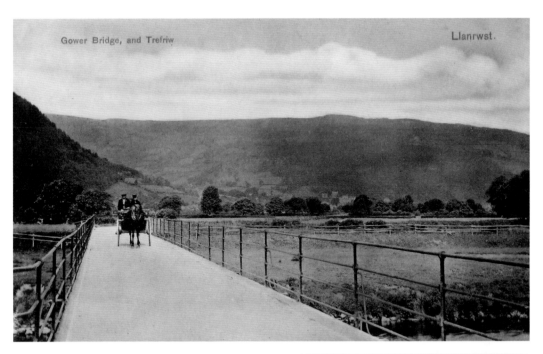

Gower Bridge, and Trefriw Llanrwst.

Gower's Bridge

The original plan for the Conwy Valley railway was to route it up the west bank of the river from Conwy via Trefriw. When the plan was changed to run the railway up the east bank, the railway company decided to give the name Llanrwst & Trefriw to Llanrwst Station. The rector of Trefriw at the time, John Gower built a road and bridge to link Trefriw with the railway station at Llanrwst. The original bridge was wide enough to take a horse and carriage but the replacement bridge built in the 1940s is pedestrian only. There was a toll house but that was demolished when the present bridge was built.

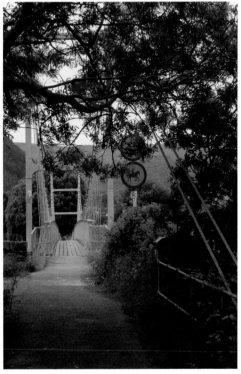

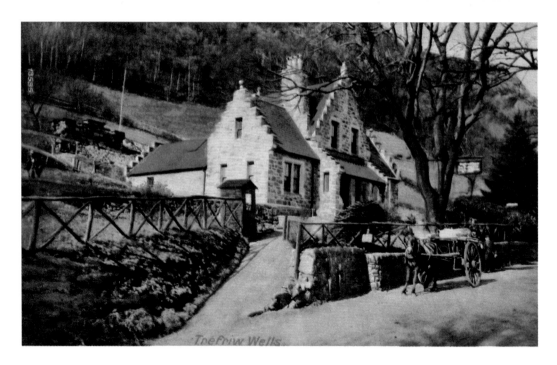

Trefriw Wells

The Spa

The mineral water caves, about two miles north of Trefriw, were discovered in Roman times. After that, the Spa remained dormant until Lord Willoughby de Eresby built a bath house in 1863 in an attempt to encourage tourists to visit the caves. There was extensive advertising at the time, much of which quoted the opinion of experts on the benefits of drinking the spa water. People flocked to the Spa in Victorian and Edwardian times. Although the Spa has been open to the public at various times in its history, it is now a commercial business and sells the spa water to outlets in many parts of the world. Each picture shows the bath house at a different time in the past.

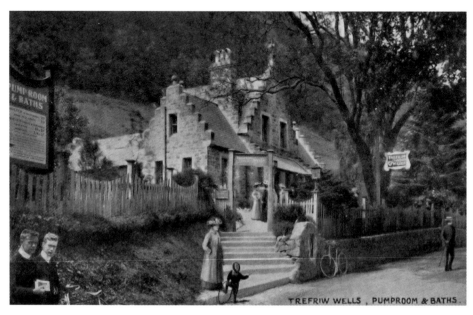

TREFRIW WELLS, PUMPROOM & BATHS.

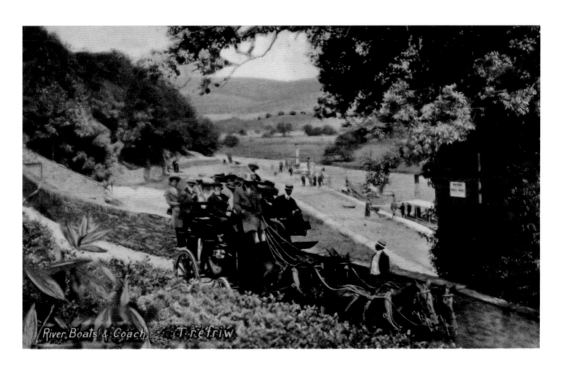

River Boats & Coach Trefriw

The Quay

Although small boats traded to and from Trefriw at least from the mid-eighteenth century, the building of a quay in 1811 and dredging of the river allowed larger ships to trade, some of which were sea-going vessels. At that time the ships carried metal ore from the mines as well as timber, wool and grain. By the late nineteenth century, Trefriw became a popular tourist destination and paddle steamers from Deganwy and Conwy brought people to the village. The steamers continued until 1939, and apart from a short revival of motor boats coming to Trefriw in the 1950s, that was the end of boats visiting Trefriw.

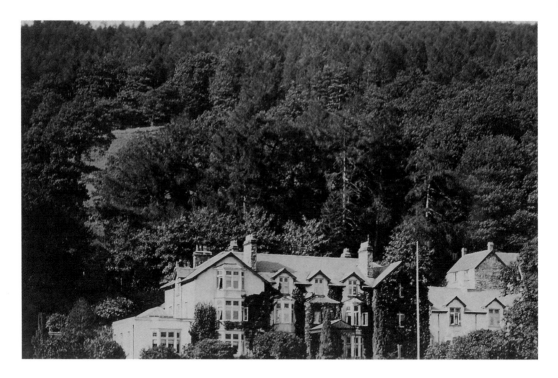

Prince's Arms Hotel

This large hotel, originally called the Belle View was built in the 1860s during the heyday of Trefriw as a tourist destination. It was built conveniently opposite the Quay and people who travelled on the steamers went there for a meal during which they were entertained by David Francis, the famous blind harpist. In the 1930s the Spa waters were made available to visitors at the hotel to save them making the journey to the Spa caves, some distance to the north. In the 1960s the hotel was renamed the Prince's Arms, so maintaining Trefriw's link with Prince Llewelyn the Great of the thirteenth century. It remains a popular venue for meals and accommodation.

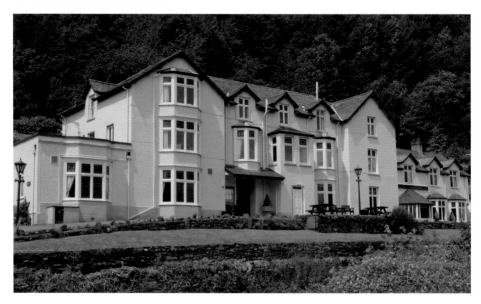

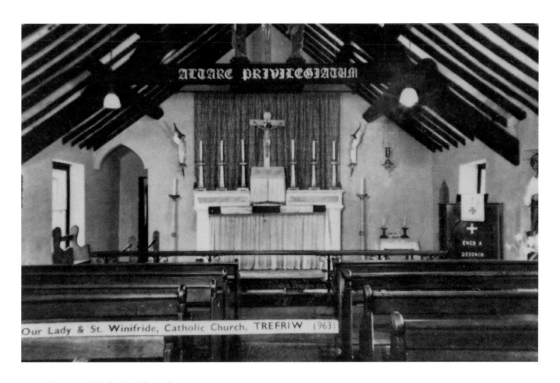

Our Lady & St. Winifride, Catholic Church, TREFRIW (963)

Roman Catholic Church

Many people from Ireland came to work in the mines at Trefriw and a sizeable Roman Catholic community grew in the village. They first met in a shed in 1921 and later in a house which was used as a church (above). In 1963 a new church was built and around the same time two other new churches were built, one in Llanrwst and one in Betws-y-Coed. In the last decade of the twentieth century these 'new' churches at Trefriw and Betws-y-Coed closed and their congregations then moved to worship in Llanrwst. The 1963 church at Trefriw is now a private house (the large building on the hillside).

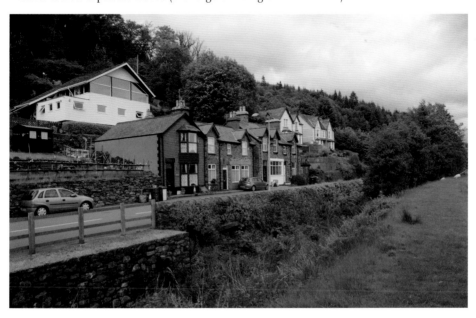

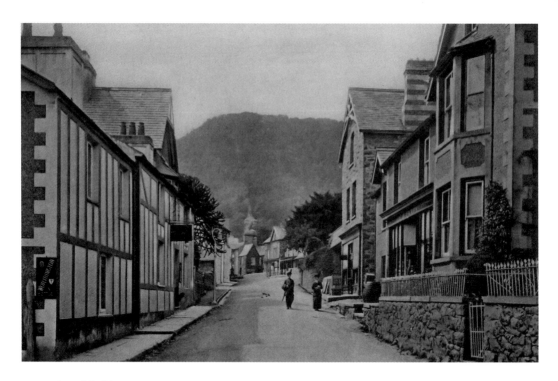

The Old Ship

Although Trefriw is twelve miles inland, the name of this pub is a reminder of Trefriw's days as the largest inland port in Wales. Before the coming of the railway, the easiest way to transport people and goods up the Conwy Valley was on the river. As well as carrying local products from Trefriw to places of large population, the ships brought in supplies such as coal to the village. Today, the Old Ship, as it is now called, provides a valuable service of drinks and meals for locals and visitors as does Chandlers restaurant next door.

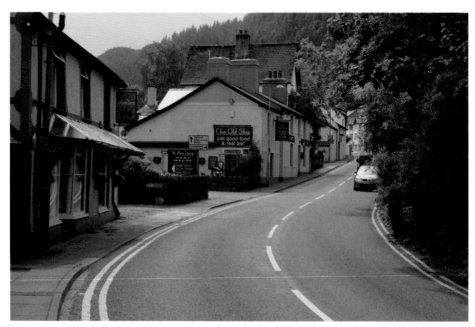

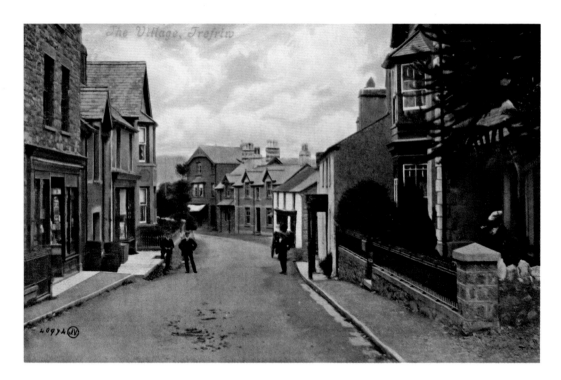

Maralyn's Butcher Shop

In its heyday as a tourist destination Trefriw had many shops as would be expected as 1,000 people visited the village every day. A stroll down the main street shows that many of the properties were once shops. Today, there are only a few shops including Maralyn's Butcher. Maralyn's is owned and run by a well-established local family who also have a shop in Tal-y-Bont (their original shop), three miles down the valley. The shop sells locally sourced produce and provides a good service to locals and tourists alike.

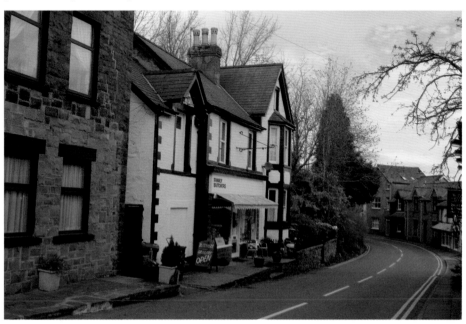

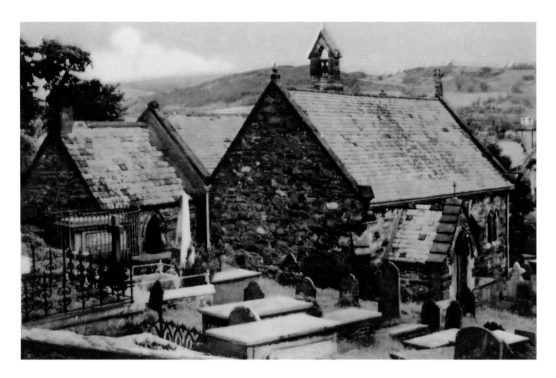

St Mary's Church

Llywelyn the Great had many dwellings in Gwynedd, one being at Trefriw. The nearest church was two miles up a very steep hill to Llanrhychwyn but Llywelyn's wife Joan, daughter of King John of England, complained about the steep climb to Llanrhychwyn. Llewelyn responded by building a church at Trefriw in 1230. Apart from a few stones, nothing remains of the original church as it was rebuilt in the fifteenth, sixteenth and nineteenth centuries. The church continues in use today as also does the ancient church at Llanrhychwyn.

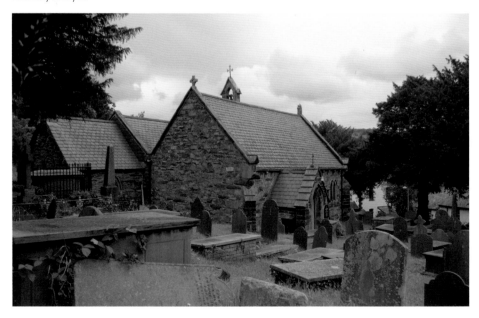

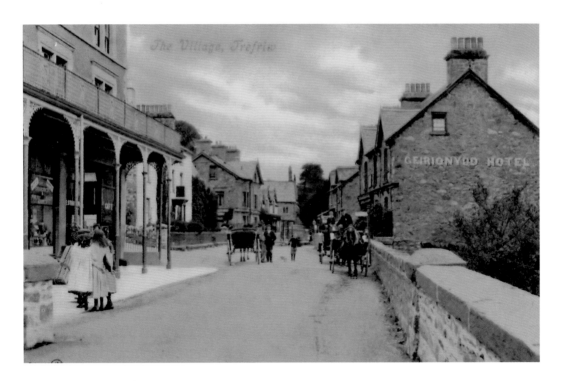

Fairy Falls Hotel

This was originally called Geirionydd Vaults and later Geirionydd Hotel, its name being derived from Llyn Geirioyndd, a lake in the mountains above the village. The area around the lake is significant to Welsh culture as two famous poets were born in the area. The first is Taliesin, a sixth-century bard and one of the first to write poetry in the Welsh language. The other is Evan Evans, a poet of the nineteenth century who took his bardic name, Ieuan Glan Geirionydd from the name of the lake, much of whose poetry took the form of hymns. The hotel was later named Fairy Falls after a small waterfall on the adjacent River Crafnant. It remains a popular venue today.

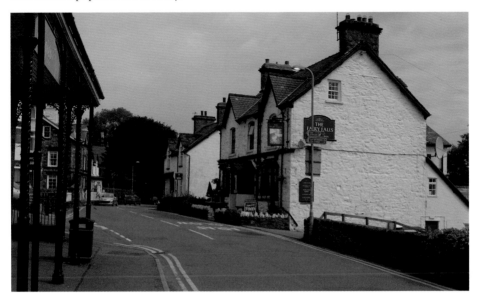

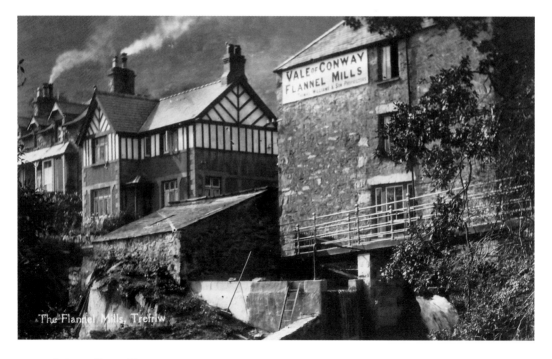

The Flannel Mills, Trefriw

The Woollen Mill

In the early nineteenth century a woollen mill was built at Trefriw making use of water power from the River Crafnant which flows from the mountains to the River Conwy. The mill was bought by Thomas Williams in 1859 and has been in the hands of the Williams family ever since. In 1970 a new building was built. It is well worth a visit to view the hydro-electric turbines and the interesting museum. There is also a well-stocked shop selling the mill's produce and a café. The mill is popular with visitors, particularly with the many coach parties which call there.

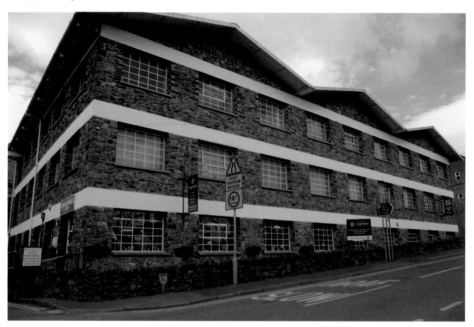

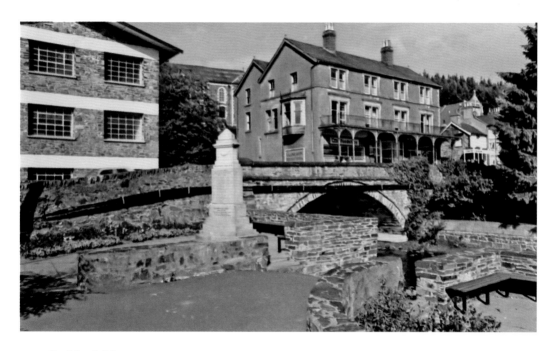

Trefriw Bridge

The bridge carries the main road through the village over the River Crafnant. There are a number of interesting features in this picture including the war memorial and Trefriw's two chapels, Ebenezer, between the shops, and the Mill, just above the war memorial. The other chapel, Peniel, can be seen on the right. When Peniel was built it was intended to include a tower and a spire, but the project was abandoned. Notice the changes to the row of buildings where the shops are.

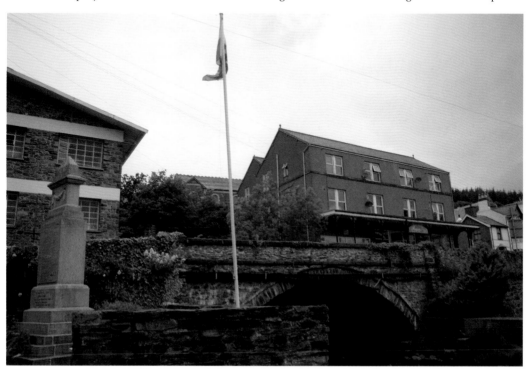

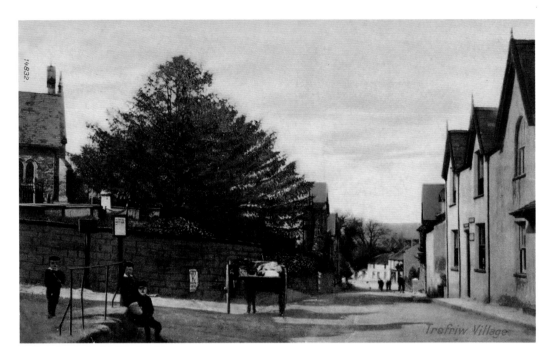

Yew Tree

These pictures show a very leisurely Trefriw, both in the age of the cart and the age of the motor car. The house opposite the church Tan-yr-Yw (under the Yew) is the birthplace and home of eighteenth-century Welsh poet David Jones. It is on the right in the old picture and the left on the new picture. The yew tree in the churchyard sums up the theme of this book. It has certainly been there all through the time of the pictures in this book and if it could talk it could tell many an interesting story.

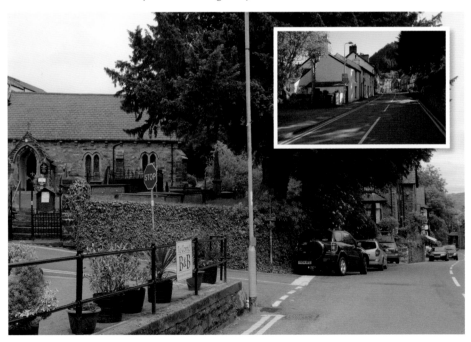

Acknowledgements

I could not have written this book without the help of many people. In particular I would like to thank Glyn Jones (Betws-y-Coed) and Pat Rowley (Llanrwst) for their exceptional help in allowing me to use pictures from their own collections and for giving me so much information. I would also like to thank Hilary Brookes, Elsie Houghton and family, Aneurin and Gwladys Hughes, Kenneth Hughes, Anne Jones, Bob Jones, Glynne and Helen Jones, Andrey Matveev, Elsie and Gwilym Roberts, Conwy Valley Railway Museum, Eagles Hotel Llanrwst, Gwydir Castle, Maenan Abbey Hotel, Trefriw Woollen Mill, for their help in many and various ways.

Photographs

The new photographs seen throughout this book were taken by me and the archive photographs are my own collection, except where indicated below with reference to the appropriate page number.

With kind permission from Glyn Jones collection:
6,7,8,10,11,12,13,14,15,16,17,18,19,23,25,26,27,28,29,30,31,32,33,34,35,36,37,38,39.40,41,42,43,45,80

With kind permission from the Pat Rowley collection:
47, 48, 50, 51, 52, 53, 54, 55, 56, 57, 59, 60, 61, 62, 63, 64, 66, 67, 68, 69, 70, 71, 72, 73, 74, 75, 76, 77, 78, 79, 83, 85, 87, 94

With kind permission from the Conwy Valley Railway Museum:
20, 21, 22

With kind permission from the Maenan Abbey:
82

Bibliography

K Mortimer Hart, *The Conwy Valley* (Gwasg Carreg Gwalch, 1987)

Peter Lord, *The Betws-y-Coed Artists Colony* (Coast and County Publications, 2009)

Michael Senior, *The Conwy Valley and Its Long History* (Llygad Gwalch, 1998)

Norman Tucker, *Llanrwst, the History of Market Town* (Landmark Publishing, 2002)